GYPSET
LIVING

Text © Julia Chaplin
© 2014 Assouline Publishing
3 Park Avenue, 27th Floor
New York, NY 10016, USA
assouline.com
ISBN: 9781614282112
10 9 8 7 6 5 4 3
Printed in China

JULIA CHAPLIN

GYPSET
LIVING

ASSOULINE

Contents

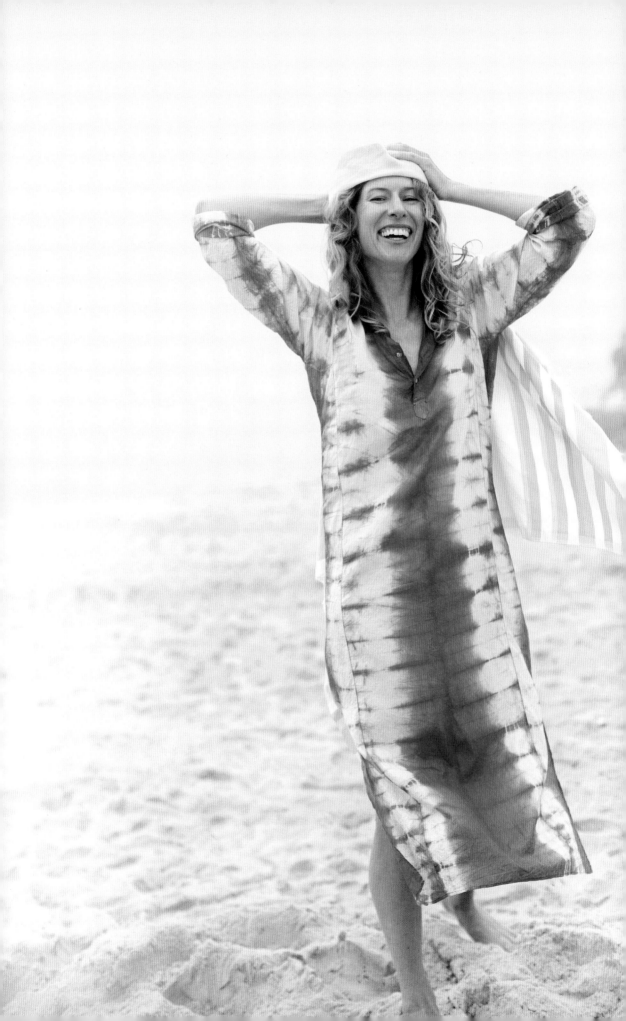

Introduction

Gyp·set n. \`jip-set
A lifestyle that combines the unconventionality of the gypsy
fused with the sophistication and speed of the jet set.

I coined the term in 2009, and in my first book, *Gypset Style,* defined the movement and its roots in the counterculture. In my second book, *Gypset Travel,* I explored the idyllic enclaves around the globe where the movement has taken hold—I like to think of it as the gypset archipelago. The book you hold in your hands now is about the groovy, unique way that gypsetters actually live—wherever it may be and however temporary. It's a close-up look at what I call homesteads. Of course, gypsetters are semi-nomadic by definition, so their homesteads tend toward the portable and makeshift. But in this book you will discover, as I did, that a yurt or a teepee can be more stylish than a penthouse apartment or a Roman Palazzo, if not more so. What's more, even the gypsetters who do own palazzos add experimental touches—tree houses, stargazing nooks—and make sure that there are always plenty of extra rooms for their nomadic friends. In the gypset mileu, experimental and luxury are one and the same. It really all depends on how you define luxury.

Gypsetters see luxury in the bohemian, the conceptual, the avant-garde—the more out there the better—and they are not alone. Architects and designers in Italy during the 1960s and 70s had the technical expertise to make beautiful furniture, but they also wanted to question societal mores. Mario Bellini championed the communal with big group-sized couches that were more like landscapes and promoted casual interactions. When asked to do an interior for a car, he presented Kar-A-Sutra with just a bunch of foam cushions—optimal for sing-a-longs and en route conversations. Superstudio was an idealistic architectural collective that imagined spaces without objects; the ultimate in anti-consumption.

The author on the beach in Montauk, New York.

The hippies toyed with a similar philosophy, but theirs was a more localized, craftsy take on freedom. They experimented by living inside homemade wooden domes, tricked-out campers, and meditating on hilltop platforms. These separate historical strands now flow together in a global gypstream.

Nomadic, tribal culture is very much a design inspiration to the gypset. While in Morocco, I was impressed by the Berber's tried and true pack list that included the bare essentials: a few carpets, leather poufs, and trays. Everything in the Berber home (or tent) is not only portable, but close to the ground, fostering community and earthiness, a sort of fusion of the conceptual Italian designers and the hippies. Here's to the latitudinal lifestyle.

But is it a personal utopia? That was my criteria while researching this book and searching for the perfect people and places to include. A utopia is by definition an imaginary place. But when you allow it to be personal, it's both a place and a state of mind, which I can confirm very much exist. To me, personal utopias are individual experiments in living that question the status quo. Whether they're successful in making the world a better place or not matters very little. It's the conceptual, living-by-example attempt that's important. For example, in Kipahulu, Hawaii, I found an off-the-grid activist farming community where the only stores are little roadside farm stands and an occasional food truck. I was there with the photographer Brian Hodges and we were immediately swept up into the social whirl, getting invited over to the homestead of a woman named Jeanne Angelheart. There was a handmade sauna and dipping pool, bamboo huts occupied by nubile farmer types, organic vegetable gardens, and a hidden beach. Personal utopia? Check. The same was true when I traveled to Inner Mongolia at the Genghis Khan Polo Club run by the German ex-pat Christopher Giercke and his Mongolian wife Enkhe. Several yurts and a few polo fields were arranged on a ridge that fused the pastoral nomadic with western luxury. Christopher, who supplies cashmere to Hermès, had outfitted the guest yurts in soft felt and Japanese soaking tubs. And in Ubud, Bali, I met the young eco-activist Elora Hardy, who builds elegant, whimsical structures made of dreams and sustainable bamboo. In the case of the band Wild Belle, contemporary nomads who are always on tour, the homestead is where the gig is. Because music is their architecture, they feel equally at home in Brazil, Jamaica, or in Tucson, Arizona.

Gypset Living is not a typical interior design book. To me, the inhabitants are as important as the habitat. I was not interested in rooms styled with bouquets of roses or arranged throw blankets. Often I was tipped off by friends, or friends of friends, to exceptional gypset dwellings. But sometimes I would just park myself at the local bar and eventually meet the right people. The images you see on the following pages are not about expensive chandeliers, particularly as there are none. But you might see some unusual crystal collections and bespoke dreamcatchers. It's more about a gypset state of mind. My hope is that as readers flip through these pages they will be inspired to live as freely as they roam.

Previous pages: The Airstream trailer gets a makeover with fuchsia paint, Indian textiles, and ocean views. The Springs, New York. *Opposite:* Good luck charm; a Hindu shrine on the island of Bali, Indonesia.

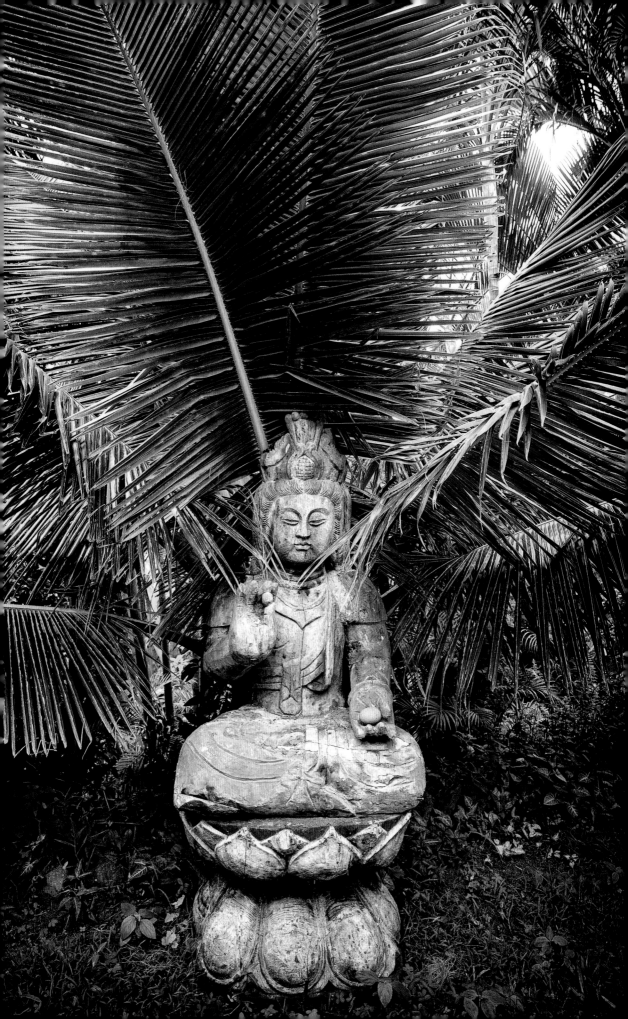

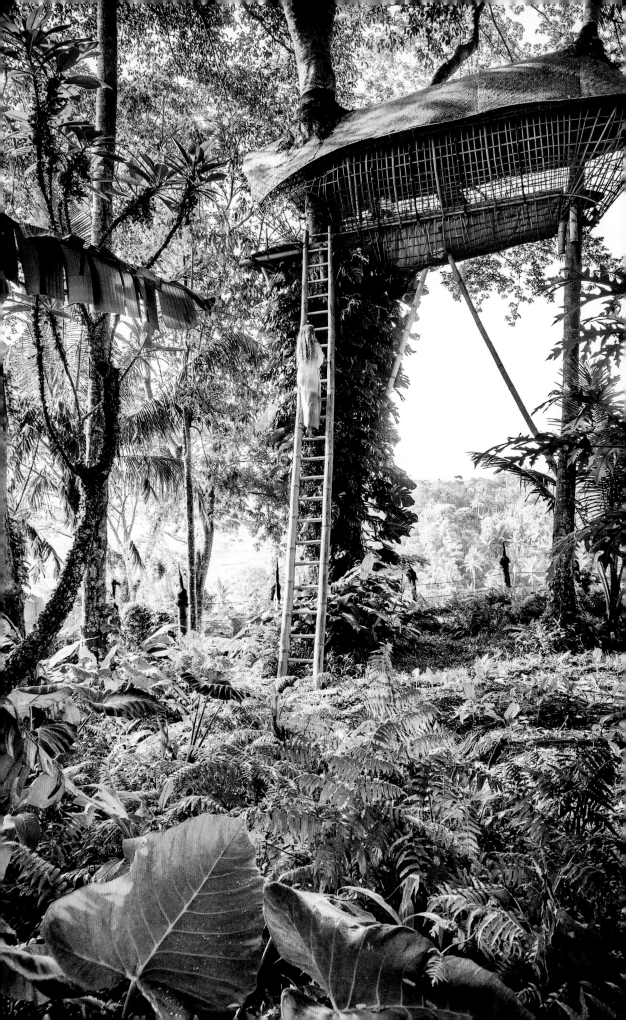

Bamboo Revolution

BALI, INDONESIA

Gypset Rule #1: If you're going to embellish your past while traveling, make sure there is no Internet connection.

I n 1971, The Rolling Stones moved into the grand Villa Nellcôte in the south of France to record *Exile on Main Street.* The rambling eighteen-room Belle Époque mansion had marble Ionic columns and Versailles-worthy ceilings, but the band and their hangers-on preferred a more casual approach to living; sitting on the floors, living out of cardboard boxes, and using the ornate dining room table for cigarette butts and bare feet. For some reason, I'm reminded of this type of glam decadence as I wander through the undulating chambers of Sharma Springs, a massive eco-tree house in Ubud, a town at the center of the Indonesian island of Bali. Built almost entirely out of sustainable bamboo, hundreds of trippy poles climb and wind throughout the towering six-story structure like an elegant kaleidoscope forest. In the middle of it all is a koi fishpond with a wine cellar underneath, and instead of walls there is just sprawling, verdant jungle, and a few monkeys. If decadent rock star sustainability didn't exist in the Rolling Stones's time, I'm happy to report that it's alive and well right now in Bali.

The person behind Sharma Springs, and for that matter, Bali's new eco-palazzo style, is thirty-three-year-old Elora Hardy. Elora grew up in Bali. (Her father is jewelry designer/entrepreneur John Hardy.) After college in Boston and a stint in New York City designing textiles for Donna Karan, she returned to her island home four years ago to start Ibuku, a design firm whose mission is to promote sustainability by building with bamboo and creating architecture that "feels good and has value." Indeed, Elora's buildings are barely buildings—they are curvilinear sculptures that

Treehouse 2.0: Diane Lion Giustiniani tests out the experimental architecture at Bambu Indah Hotel in Ubud, Bali. *Following pages (left):* A tear-shaped door in Sharma Springs, a sustainable bamboo home designed by young eco-architect Elora Hardy. *Right:* Swingers only; a bedroom in Sharma Springs.

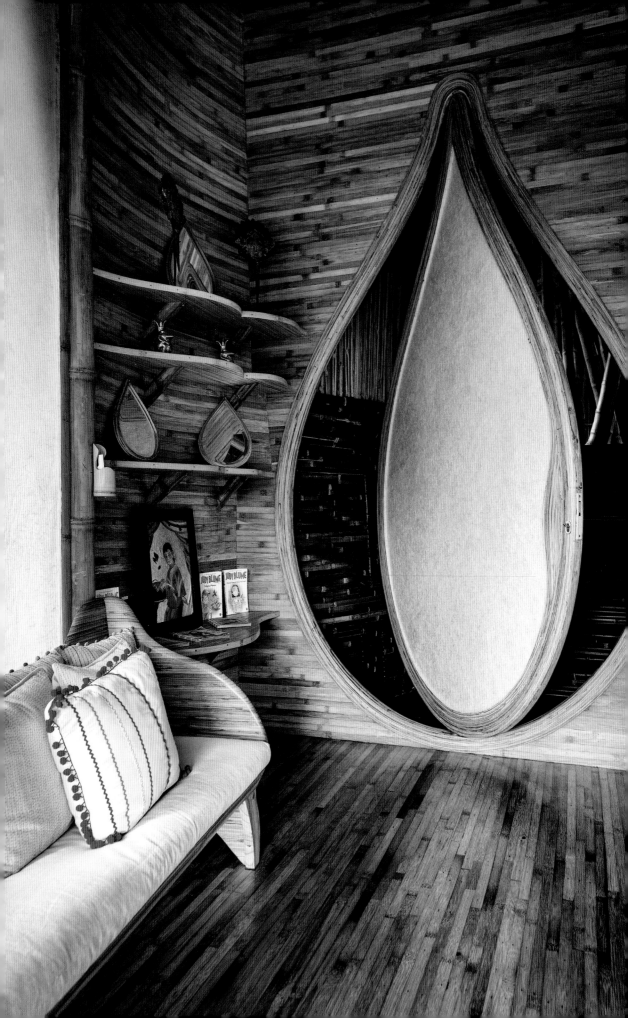

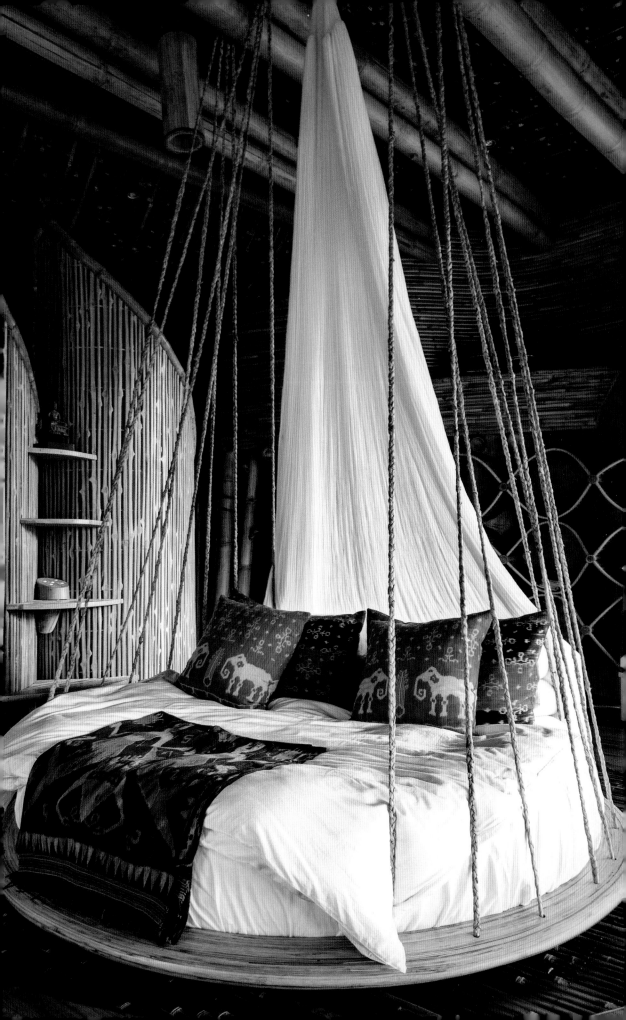

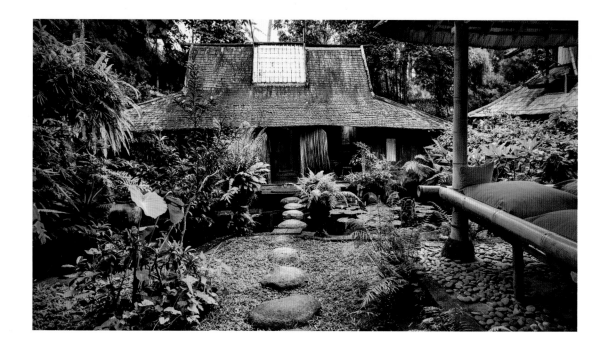

ooze experimental luxury and creative energy from every shoot and beam. These are not your usual South Sea Tiki huts.

If the 1960s hippie generation exiled itself to Bali to drop out, get tan, and generally live on the cheap, Elora's generation is about rescuing this spiritual paradise from its too many lovers. One needs only get caught in the standstill traffic found in the tourist hubs of Kuta and Seminyak on the south coast to see tourist development run amok. The beaches there are bricked in by a phalanx of bland, cheaply-built vacation villas, condos, and hotels marching inland to overwhelm Bali's rice fields and temples. Infrastructure seems nonexistent. Every time I stand in the ocean hoping for a soulful connection, potato chip bags and other bits of trash washes up around my ankles. The ocean is so polluted in the rainy season that I'm advised to use disinfecting eardrops after every swim. Not exactly my idea of gypset.

So, naturally I was heartened to meet Elora and her eco-pioneer peers. I find her one morning at her house overlooking the Ayung River Valley deep in the lush Ubud forest. It's not really a house at all but an "upside-down basket" made of woven bamboo. It's only one airy room, but one that is as chic as any Parisian atelier. Elora's long brown hair and girlish laugh at first suggests laid back hippie, but I find that she's actually hyper practical: a determined activist working long hours on ambitious projects including Green Village, a nearby eco-housing development, as well as the progressive Green School, started by her father and stepmother, with bamboo desks and a solar-powered automatic teller machine.

Above: Guests at Bambu Indah stay in Javanese bridal huts.
Opposite: Good reception: the cocoon-like entrance to Bambu Indah Hotel in Ubud.
Following pages: The exterior of Sharma Springs designed by Elora Hardy.

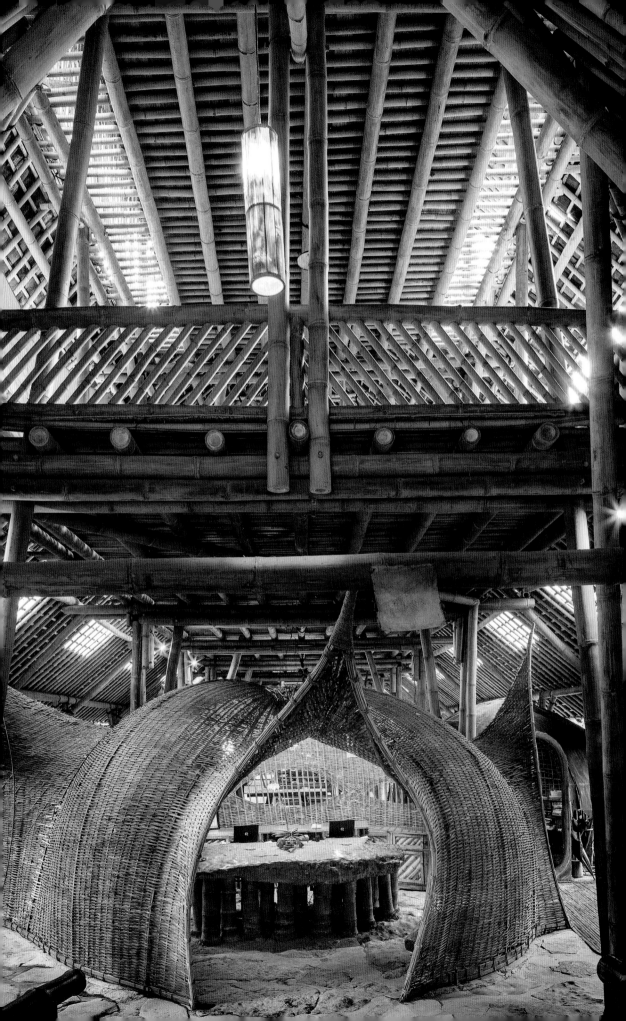

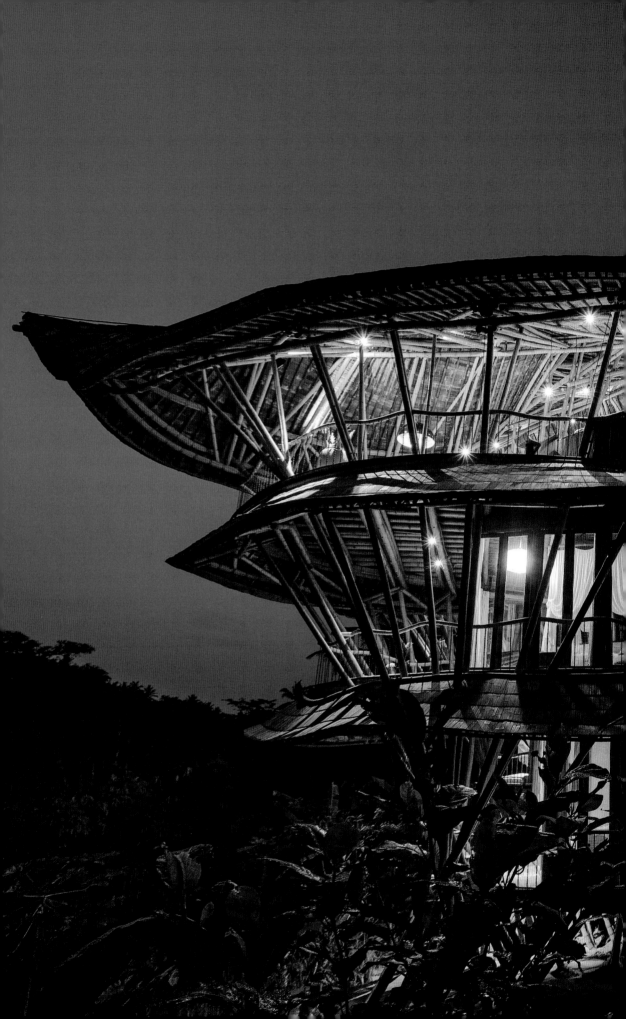

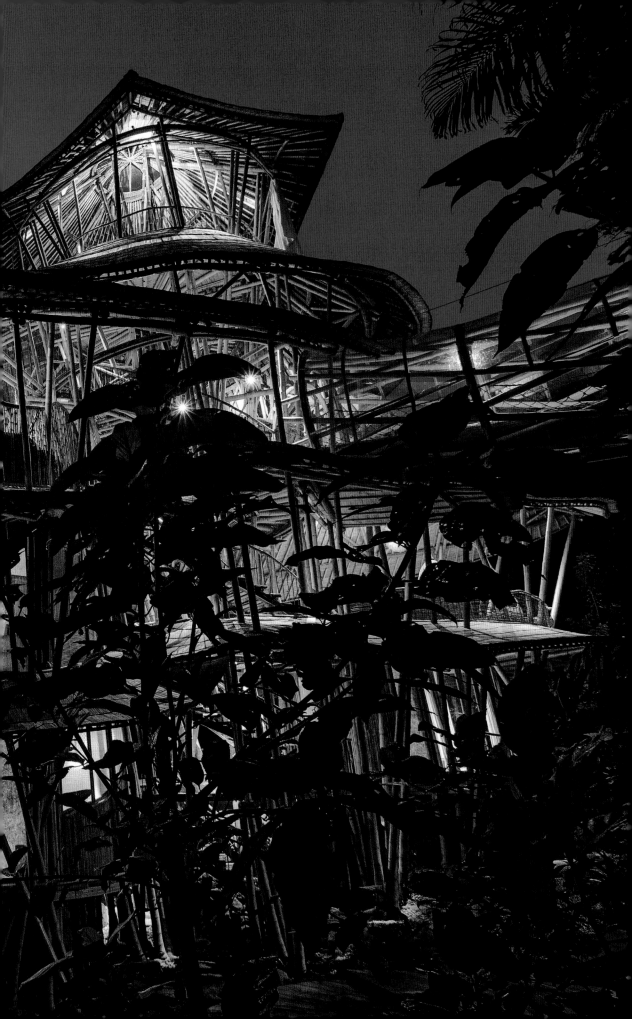

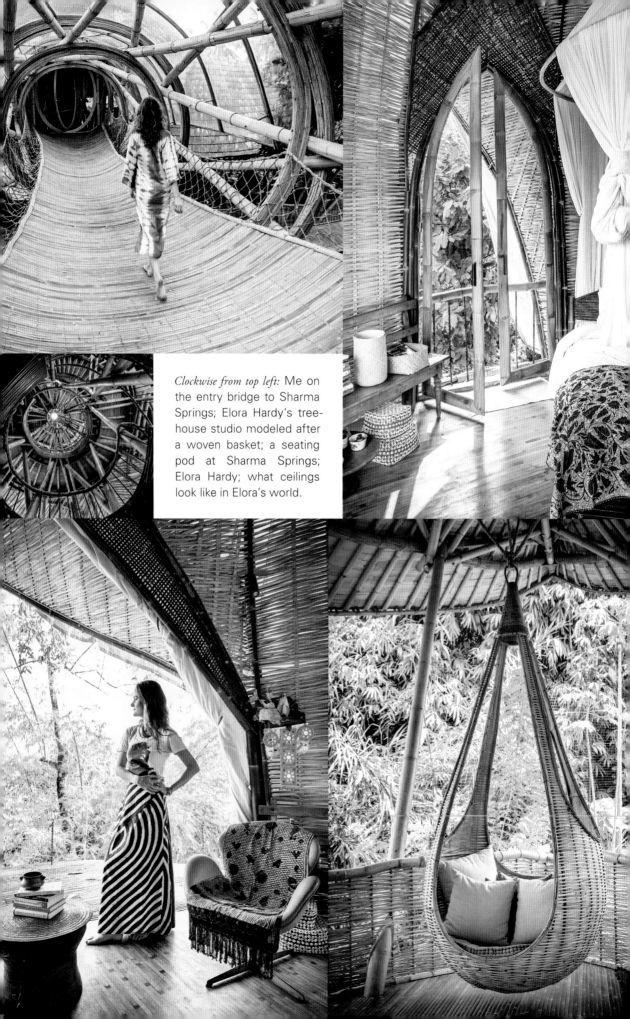

Clockwise from top left: Me on the entry bridge to Sharma Springs; Elora Hardy's tree-house studio modeled after a woven basket; a seating pod at Sharma Springs; Elora Hardy; what ceilings look like in Elora's world.

"I didn't know anything about architecture," Elora admits, sitting cross-legged inside the experimental bamboo yurt she designed herself. "I approach it all as an outsider, which allows a certain freedom." It's part of a compound she shares with her brother Orin, a permaculturist, and Rajiv her husband. He was a yoga instructor in Manhattan when they met during one of his classes, but he's currently living in Philadelphia and finishing up medical school there.

Elora credits her dreamscape style to a childhood spent in Bali with artist parents. They'd hang out in various artisanal villages and crafted things like Batik bedspreads and carved wooden dolls. Instead of family trips to Disneyland, they'd travel to nearby islands like Sumba and Sumatra, or visit cashew processing factories on Bali. "If I were to study architecture, I would study tribal architecture," said Elora, who prefers designing by building straw models, not CAD plans.

Intentionally or not, Elora is following in the footsteps of the progressive architects of Bali's past. When Bali emerged as a tourist destination in the 1970s, a forward thinking developer named Wija Waworuntu brought in two architects, Geoffrey Bawa and Jeremy Muller—from Sri Lanka and Australia, respectively—who fused traditional island designs with Western ideas of luxury. They riffed on the typical Balinese family compounds and villages with clusters of small outbuildings and temples, using local materials and craftsmen.

But Elora's biggest influence is her father John. I'm staying across the lawn from his tree house in a modernist glass pagoda that's part of his Ubud hotel, Bambu Indah. The hotel began as John's family compound, and he still holds court there. I find him at the reclaimed wooden community table in the restaurant, an open-air bamboo structure with harp strings attached to several of the poles in case one has the urge to strum a tune. John is a shrewd businessman and an outspoken and inquisitive activist who built a multi-million dollar jewelry company, sold it a few years ago, and allocated the proceeds to his environmental projects, including the Green School. Every time I mention something in conversation, he breaks out his iPhone and fact checks it. He Google searches the term "gypset" and matches my face to the ones on his screen. "Hmmm," John says. "It does look like you." I'm relieved that I've followed Gypset Rule #1 and haven't embellished my past—too much. Bali has Wi-Fi almost everywhere you go. Crashers beware.

Actually, I would advise crashers to go legit on this one and make a reservation. Bambu Indah is one of the coolest places I've ever stayed. Ironically, the swank Four Seasons is just a few minutes walk up the Ayung River Valley, but Bambu Indah somehow feels more luxurious—in a gypset way, of course. For my morning swim, I grab a rope swing conveniently tied to palm tree and plunge into the fresh water pool that is filtered using an elaborate rock system—no chemicals. Guests stay in vintage Javanese bridal huts that are landscaped among the rice paddies, vegetable

gardens, and fruit trees that supply the restaurant. Experimental architecture abounds, but my favorite is the Sumatran-style longhouse. At the hotel, it's used for yoga and chilling out, but its primordial bones of black bamboo and mane of alang-alang grass on the steeply pitched roof make it seem like the architectural love-child of a vampire and a water buffalo. John said his inspiration was "the cosmic." Very cool.

That Bali's eco-movement is centered in Ubud is no surprise. Ubud has been the nexus of the island's art scene since the 1930s when the royal family invited Western and local artists and intellectuals to come and stay. Today, the main streets are dotted with yoga studios, healers called "balian," and shops selling sarongs and harem pants. To soak up Ubud's vibe, I went for lunch at the raw, vegan café Alchemy, the town's version of Studio 54. (Instead of cocaine, the substance of choice here is Maca, an energy-enhancing Peruvian root.) On the shaded terrace, a group of Star Trek yogi-types with bald heads and plucked eyebrows were having a jam session on a daybed with a collection of UFO shaped Hang drums—new age-y percussion instruments that sound like psychedelic harps. At the next table were four tousled-haired young women with yoga mats and Lycra hot pants grazing away at heaping bowlfuls of organic salad. And over by the raw chocolate counter, a ripped guru dude in tight Ikat-print hip huggers was peacocking around making eye contact and smiling. In the middle of it all, a chalkboard had been decorated with the day's mantra in a swirly font: "Your body is a temple. To eat intelligently is an art." Definitely more *Eat, Pray, Love* than sex, drugs, and rock 'n' roll. Or as John Hardy likes to say of the quasi-spiritual seekers that maul Ubud where the Bali part of the movie was filmed, "Eat, Pay, Leave."

An unlikely corollary to Ubud was my next stop, the surfer enclave of Uluwatu, located on the Bukit, a peninsula just south of the capital city Denpasar. Jutting out into the Indian Ocean, Uluwatu has some of the best surf breaks in the world. The pros migrate here after the winter season in Hawaii. Padang Padang is the main gathering spot. To get to the beach, I had to weave down a steep cliff through a terraced warren of warungs (little shops, cafés, and bars) with front row seats to the waves below. It was low tide when I reached the bottom, so I was able to scramble through several craggy caves that led to a secret beach with nothing but a castaway coconut sculpture some poetic sunbather had left behind. This was the Bali that I had hoped to find.

That night, I hopped on my scooter, driving past the green valleys and overgrown temples on the way to dinner at the local hangout, Cacho's, a Mexican café owned by a Puerto Rican guy also named Cacho, who, judging by his exuberant commentary during a surf video playing on the wall, is friends with all the old North Shore surf legends. I meet Tim Russo, a surfer expat from Maryland who owns Uluwatu Surf Villas where pros like Rob Machado and Tom Carroll like to stay. Like

Cherry (seated) and artist Ashley Bickerton at home in Uluwatu, a surfer's paradise on the Bukit peninsula in Southern Bali. *Following pages (left):* Ashley Bickerton's tricked out tribal/ hunting lodge sitting area. *Right:* The Sumba House at Bambu Indah.

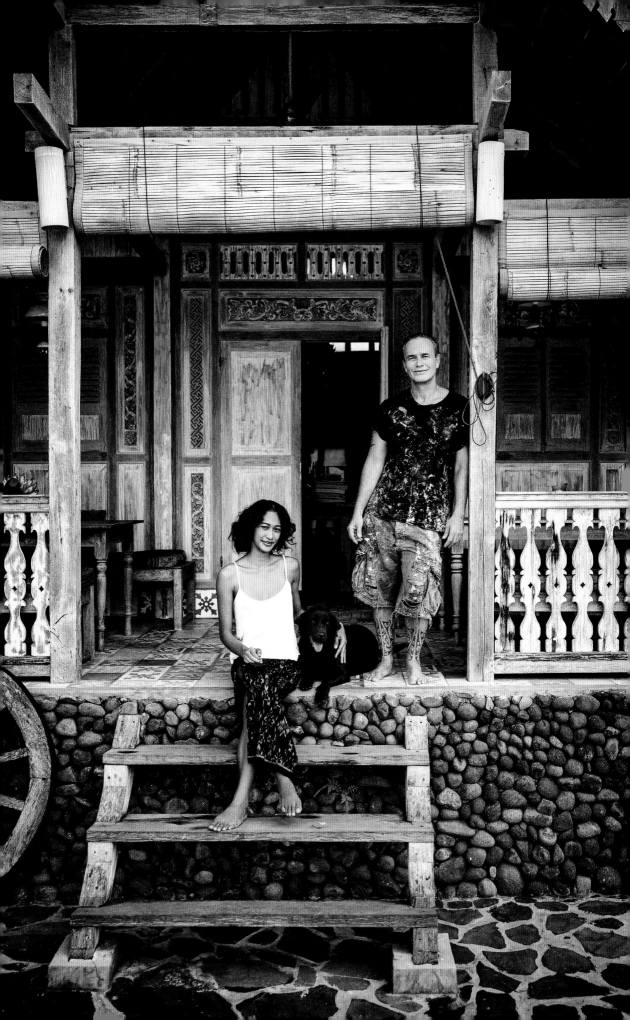

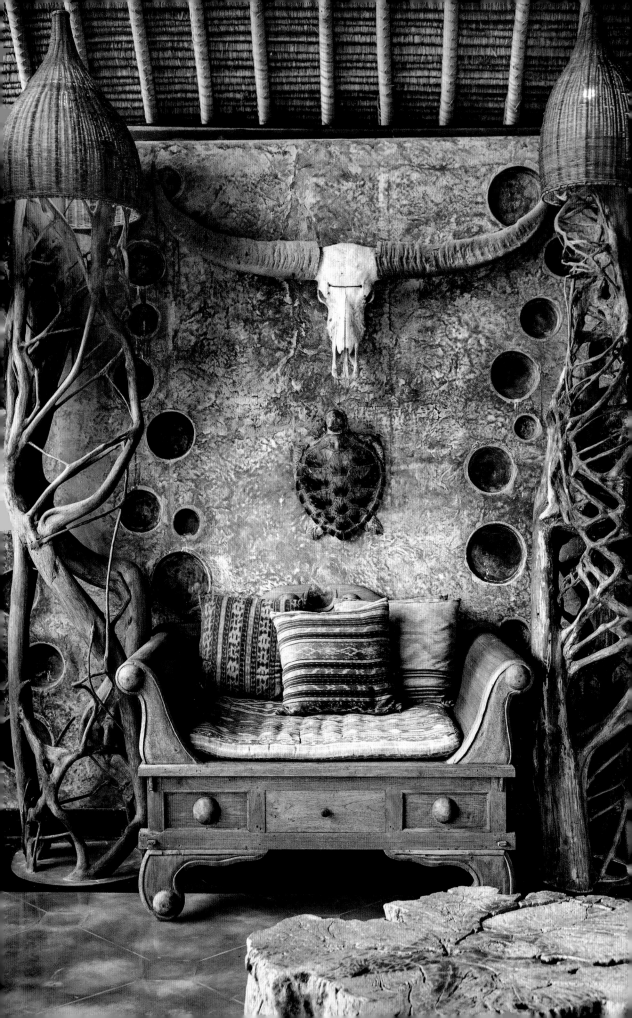

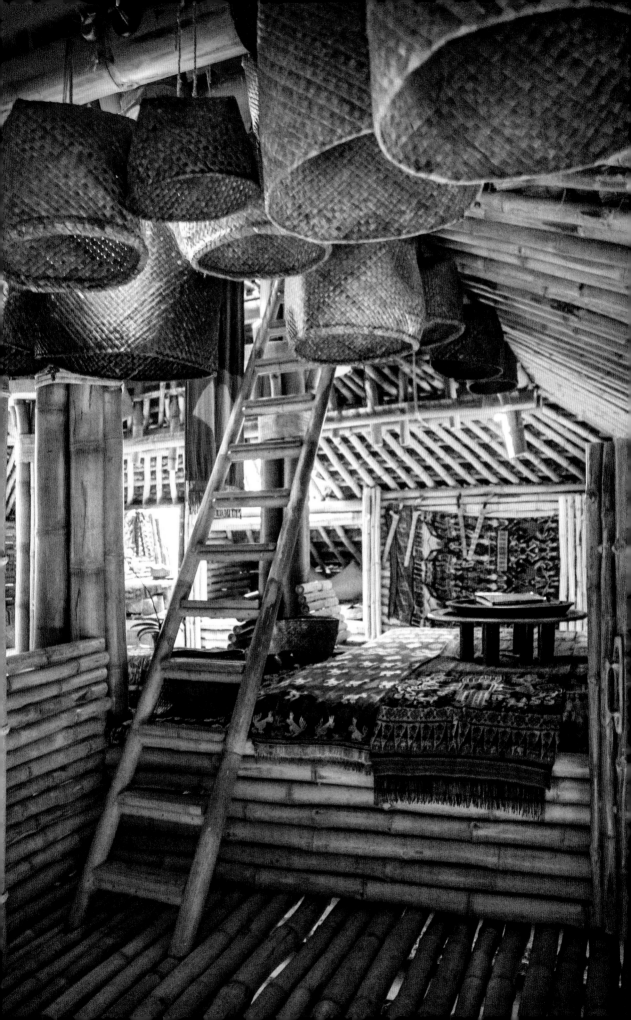

Right: Balinese Jimi Hendrix?
Left: Gypset family Morgan Roberts, Jane Hawkins, and Peter Decker at their home in Ubud.

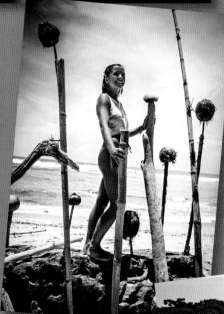

Above: My idea of sustainable branding.

Above: A feral traveler girl enjoys a secret cove at Padang Padang Beach.
Opposite: Seewah and Tim Russo relax at the Uluwatu Surf Villas, where pro surfers Rob Machado and Tom Carroll stay when in town.

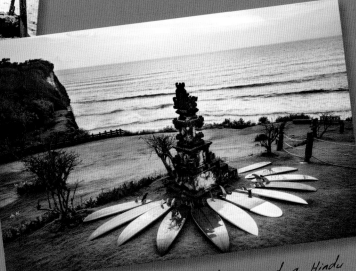

Above: a quiver of surfboards surround a Hindu temple at the Uluwatu Surf Villas.

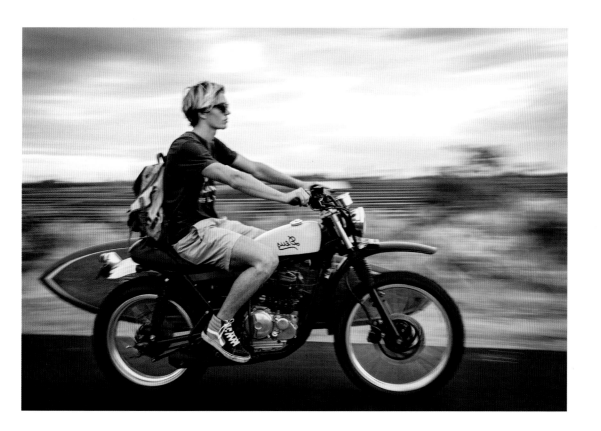

Elora, he has fused his passion for Bali with ecology. Project Clean Uluwatu is a non-profit run by him and other surfers that help build infrastructure to keep sewage and garbage from polluting the local breaks. While we are talking I notice a large portrait of a naked obese man covered in blue paint riding a scooter and I recognize it immediately as the work of artist Ashley Bickerton, who I featured in my first book *Gypset Style*. Just like Picasso did in the south of France, Ashley traded the artwork for a life's supply of burritos and frozen margaritas. Not surprisingly, he is sitting at the table nearby. He's with a young Balinese model/lawyer named Cherry, who he introduces as his new wife. Ashley, an accomplished surfer and internationally respected contemporary artist, has lived all over the world—Brazil, Barbados, New York City—but it's Bali where he's put down roots. I ask him why. I know he sees the downside: crowds, pollution, and villa-fication—the proverbial man on the motor scooter—obese, nearly naked, and painted blue.

"Artists have antennae that we put out into the air to define electromagnetic currents and places with an upwelling of creative nutrients," Ashley explained. "Whether it be histories, ethnicities, cultures, and topography itself, Bali's got it in spades." This reminds me of something Elora had told me back in Ubud. "Bali has an aroma to it that attracts people," she said. And it's true: the longer I spend on the island, the more I begin to understand what they mean.

Above: A surfer drives a custom Deus Ex Machina bike past the rice paddies in the village of Canngu, in the south of Bali. *Opposite:* Roadside Hindu-pop.

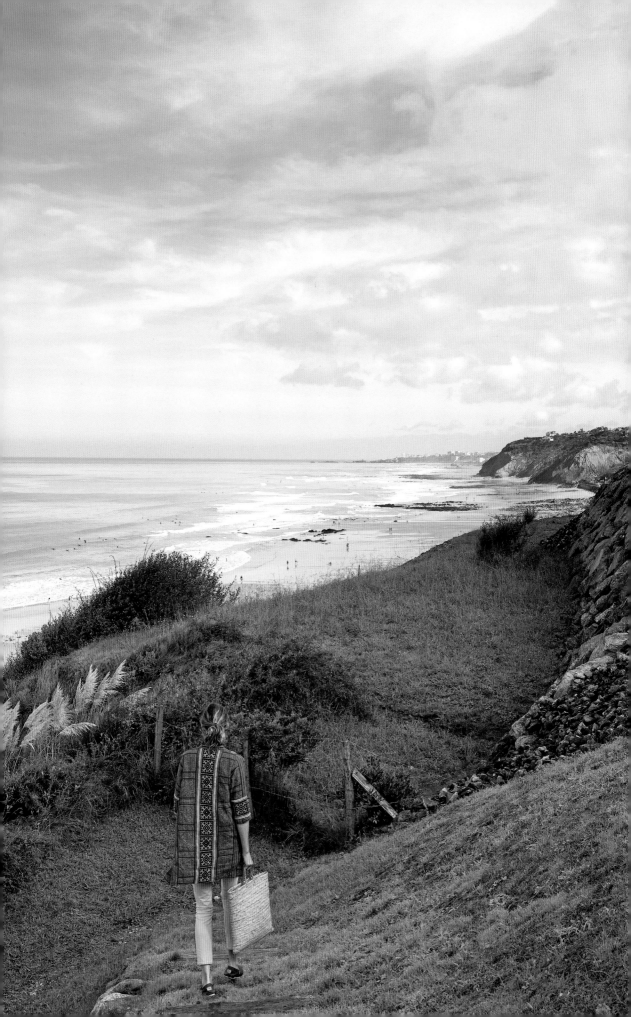

Basque Surf Charm

GUÉTHARY, FRANCE

Gypset Rule #2: If a stranger invites you to stay at his house and it's on a good surf break, always accept.

Alexis de Brosses answers the door in nothing but a pair of khaki shorts and a smear of zinc sunblock over his nose. He's a French entrepreneur/gypset bachelor who owns a cosmetic company and spends his time rotating between Bali, Paris, Peru, and Ibiza. Through friends he's invited me to stay at his house in Guéthary, a small fishing port on the Basque coast of France.

I follow Alexis down a long, narrow hall lined with dozens of surfboards lashed to the wall with bungee cords. He leads me into a modernist Turkish bath with a line showers and dozens of wetsuits of varying sizes and shapes hanging on a piece of driftwood. "Help yourself," he says and bolts for the door. "I've got to go surfing now. The tide is coming up. I must hurry. Au revoir."

In the 1800s the house was a shoe factory, but Alexis has transformed it into something resembling a luxury surf camp. There are pink hammocks tied to the I-beams, Hindi deities with leis around their necks, and a Hobbit-esque dorm with a dozen bunks carved out of knotty tree branches. A cook is in the kitchen baking a gluten-free rhubarb pie. I wander upstairs and find a hall with several fuchsia doors. Inside one, a Parisian woman is taking a nap. She mumbles something about being here for a yoga retreat. A few more occupied rooms later, I claim one with a single mattress on the floor made up in baby blue terry cloth sheets.

When I finally walk outside onto a deck perched at the top of a grassy cliff overlooking the impossibly blue Atlantic Ocean, Alexis's urgency sinks in. It's Guéthary's main surf break

Here I am on the cliffs by Parlementia, Guéthary's main surf break.

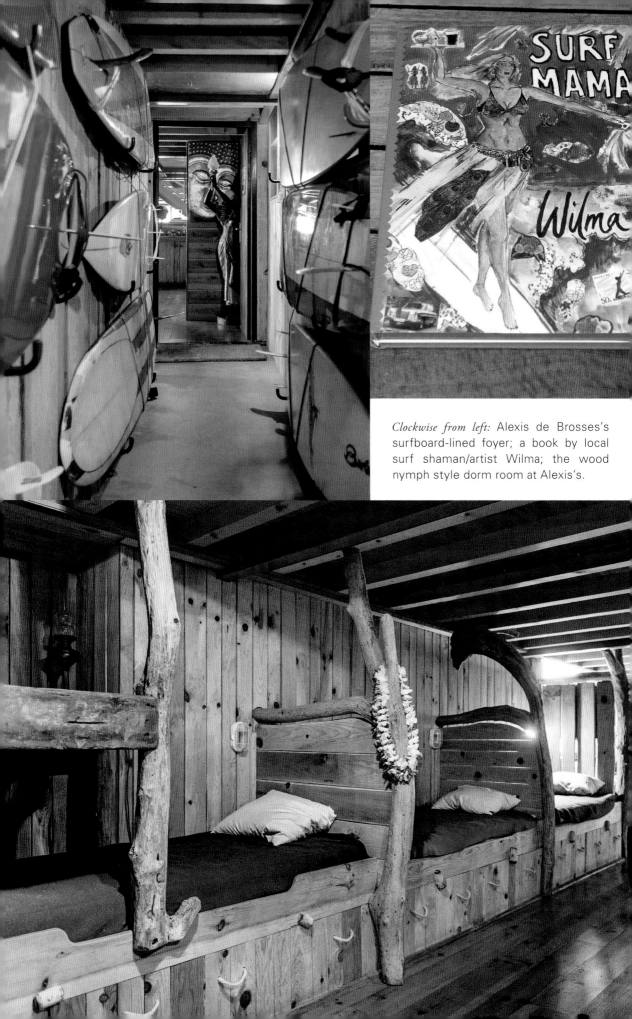

SURF
MAMA

Wilma

Clockwise from left: Alexis de Brosses's surfboard-lined foyer; a book by local surf shaman/artist Wilma; the wood nymph style dorm room at Alexis's.

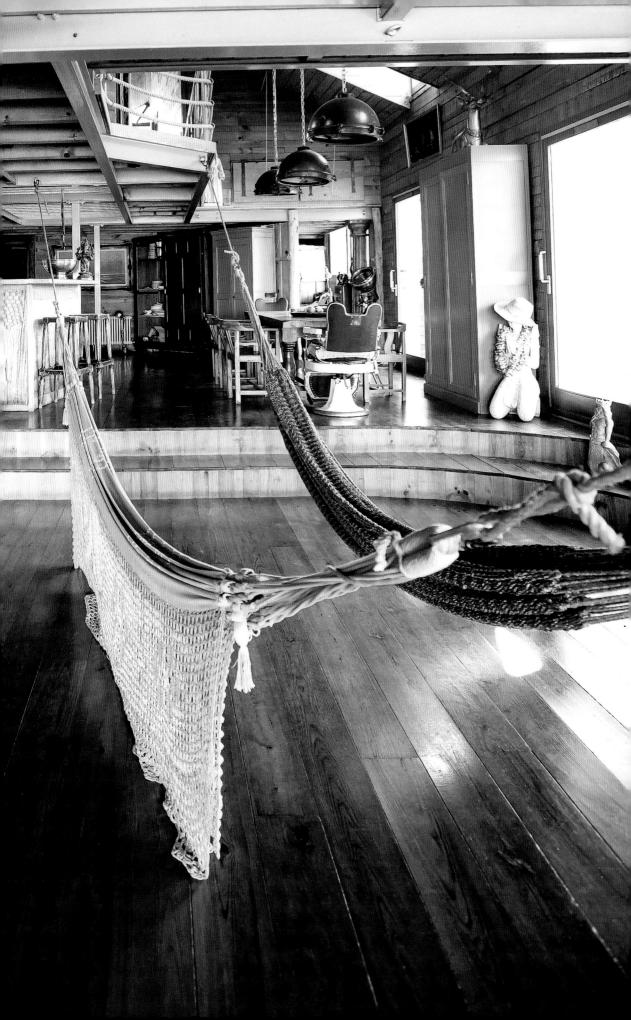

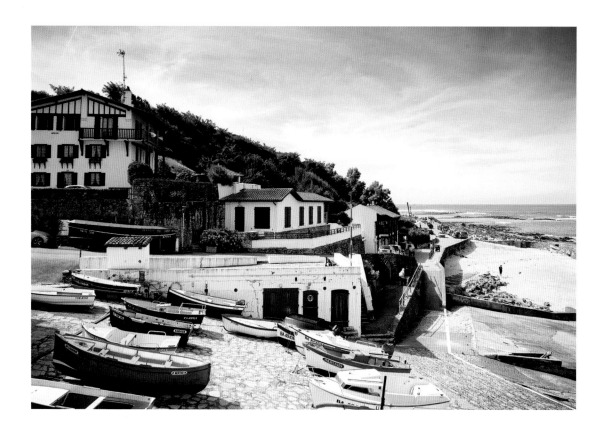

Parlementia, with an organized wave peeling out in perfect sections. The surfers look like little dots playfully whizzing back and forth across the glassy face, and I'm pretty sure one is Alexis.

I notice a film crew in the yard next door prepping a bunch of surfboards for a shoot. The boards have small motors built into the back. An American named Kenny introduces himself as Alexis's neighbor and tells me he's the European rep of Lightening Bolt Surfboards, and his partner is Jonathan Paskowitz. Jonathan's family has run the Paskowitz Surf Camp in San Onofre, California, for so long that they're considered surf royalty. And it occurs to me that this little patch of Guéthary where I'm standing is the surf equivalent of Park Avenue, the best address this side of the Atlantic. What luck!

Guéthary is a rare surfer's paradise that's happening now. It wasn't better in the 1960s and 70s, and it hasn't been ruined. Most tourists are content with staying in Biarritz, the ritzy aristo-playground where Napoleon built his summer palace, just twenty minutes north. But the cool French fashion crowd (as well as a few undaunted from Brooklyn and Bolinas) has quietly migrated down the coastline to Guéthary. A refuge from status-obsessed Mediterranean hot spots like St. Tropez and Sardinia, they've dubbed this area in the foothills of the Pyrenees "the French California" for its mellow attitude, laid-back lifestyle, and general good vibes. (The weather, however, is very un-California with unpredictable gusts and the possibility of pounding rain all year round.)

Previous pages: Alexis's luxe surf commune; hammocks tied to I-beams, splashes of fuchsia, a group-sized dining table, rope railings, and sunhats for everyone.
Above: The fishing port in Guéthary.

"It's wild, authentic, rude, and healthy," said Nadege Winter, a former PR director at Colette who is part of the recent wave of Guéthary arrivistes, a fashion insider who's weary of life on the inside. "Every time I arrive in the Pays Basque, I am exhausted for twenty-four hours. I feel it's like all the Parisian stress and frenzy that's getting out of my body. But afterwards I feel like a bird. It's the only place where the rain is not a pain for me. Where I can feel so close to Mother Earth." Nadege has taken up longboarding and with her boyfriend, started a summer music festival in Biarritz called Big, featuring musicians like Neil Young and The Dedicated Nothing.

After the next day's wave-riding session, Alexis takes me to lunch at Kostaldea, an outdoor café with a view of the action at Parlementia. It's a full on après-surf fashion show. A handsome shredder pulls up on a moped wearing a well-tailored Japanese wetsuit and espadrilles—not flip-flops. Others are lazing around the bright blue picnic tables in logo-free retro sunglasses, slightly grown-out, sun-bleached hair, and short, slim, James Bond-style swimming trunks. One guy's T-shirt reads: "Guethappy."

We order the regional specialties: *crevettes a la plancha* and *Serrano et sa tartine tomatee.* Alexis is eating lunch while balancing in lotus position on the bench. He has the funny quirk, as do most surfers I meet here, of looking over my shoulder while talking. But I realize he's just scoping the waves, vetting an opportune moment to paddle back out. We talk about Bali, energy vortexes, and the surfer's Shangri-La where I'm staying. "It is for my friends," Alexis says explaining that the bedroom with the view of the street is his by choice: "Otherwise I would be so tempted by the sight of waves I could not sleep."

Behind our picnic table at Kostaldea are the remnants of Guéthary's former life. It was a swank resort town in the 1920s. Opulent casinos were built along the Atlantic as party grounds for celebrities like Charlie Chaplin and Eugene O'Neill, and Bauhaus legends Paul Klee and Wassily Kandinsky. But the Great Depression stopped the music, and soon businesses shuttered and the well-heeled pushed off to the French Riviera. Guéthary fell into semi-abandoned neglect until the 1960s when the world-class breaks along the Cote Basque were discovered.

Today, many European surfers keep pied-à-terres in the dilapidated casinos that line the beach. With their elegant art deco lines and weather-pocked facades, they look like vintage cruise ships run aground. The apartments inside are typically small and have a cramped cabin feel, but they are prime and affordable real estate for surfers who commute from Paris or Madrid on news of a sunny day or a building swell. At night, there are several Michelin-starred Basque restaurants in the area to choose from. Fine dining is a completely guilt-free experience after spending a calorie-expending day battling the surf.

Following pages (left): A Basque chateau with an heirloom writing desk and surfboard.
Right: Lolita Falicon relaxes between surf sessions. Her parents, both surfers, bought the mini-chateau to be closer to the waves.

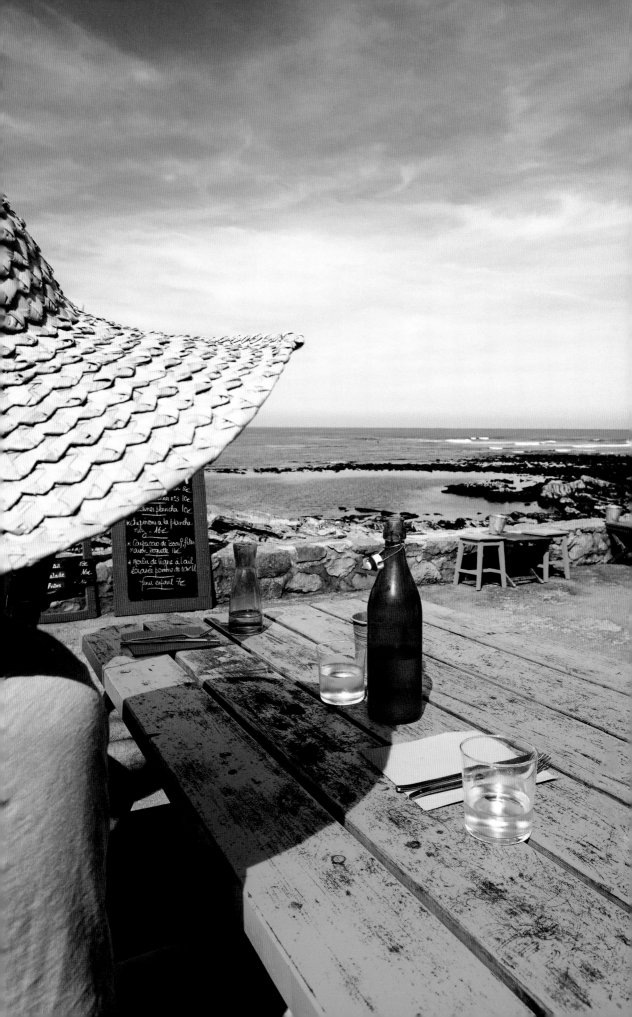

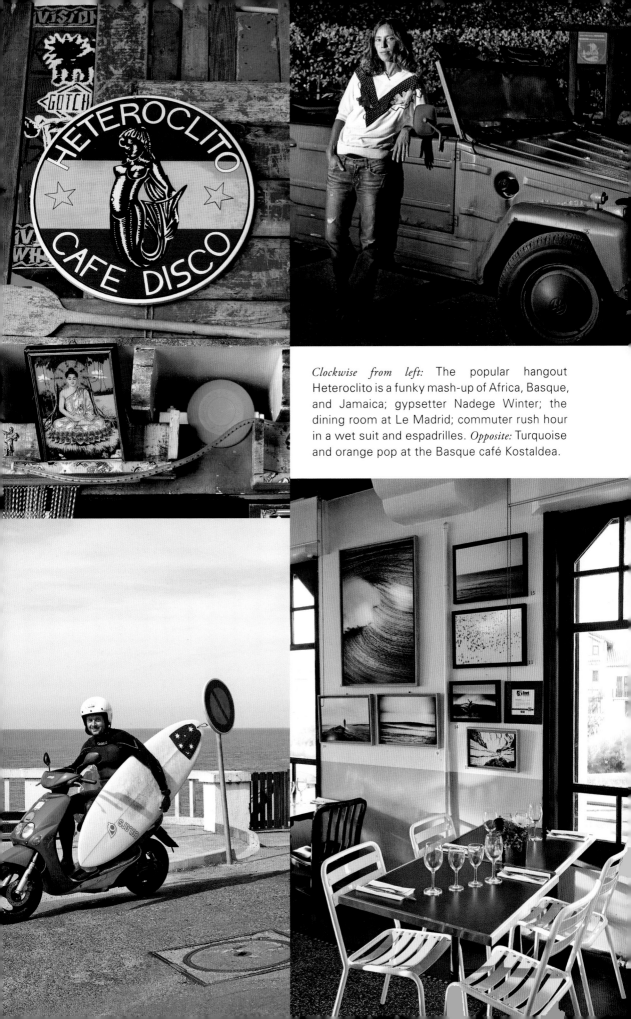

Clockwise from left: The popular hangout Heteroclito is a funky mash-up of Africa, Basque, and Jamaica; gypsetter Nadege Winter; the dining room at Le Madrid; commuter rush hour in a wet suit and espadrilles. *Opposite:* Turquoise and orange pop at the Basque café Kostaldea.

The village of Guéthary has a fairy tale quality. There's just one main road, and it's paved with cobblestones. Along it are cafés and surf shops housed in old, traditional Basque fishermen's homes with pitched red roofs and painted half timbering. Palm trees grow freely among the windswept evergreens. Around the rocky tide pools down by the sea, hippies strum guitars and picnic on duck pâté and red wine.

This being France, many of the surfers crash out at large family estates. I meet Xavier, a French DJ just back from Burning Man, at his grandparents' chateau. He and a group of friends from Paris have just returned from a day of surfing in Hossegor, a surf spot on the far side of Biarritz, and are sunburned and ready for a beer. Everyone is being careful not to break the glass cabinets and framed photographs. A woman named Julie, who looks like Jean Seberg in *Breathless*, but with longer and salty hair, attempts to protect the frilly heirloom couch by spreading a sandy beach towel over it.

Xavier decides that the better place to start the evening is at Le Madrid, a hotel and restaurant that opened a few years ago in the center of town. A traditional Basque building with blue trim, it's a microcosm of the gypset scene. I take a seat at the bar, decorated with arty black and white surf photos on the wall, and I order a glass of local red wine and some *chipirones* (tiny squid). The bartender asks me how my lunch was and it clicks that he was the surfer on the moped in espadrilles. The guy on the stool next to me turns out to be the one I shared a wave with during my morning session. It's the opposite of the trendy nightclubs in St. Tropez. The crowd is sun-kissed, nubile, and healthy, but instead of oligarch bling and Kardashian microdresses, they're low-key in skinny jeans and army coats. But the biggest difference by far is that the people in Guéthary are really nice. (Note to self: Come back next summer.)

Previous pages: Friends Julie Boulanger, Alexandre Delamadeleine, and Xavier Manuel Magescas in awe of Guéthary's sunset. *Opposite:* Après surf; Julie Boulanger, Alexandre Delamadeleine, Simon Leroy, and Xavier Manuel Magescas gather for cocktail hour on the patio.

Exotic Elegance

MARRAKECH, MOROCCO

Gypset Rule #3: Don't lounge with your shoes on.

From trendy South Beach nightclubs to glitzy Moscow high-rises, when the mood calls for something exotic, sexy, and bohemian, somehow Morocco is the go-to reference. Which seems really ironic to me as I walk around the narrow alleys of Marrakech, with some women wearing hijab headscarves and the call to prayer ringing out through the medina. Hunks of goat meat hang dripping in the market stalls, and every few seconds you have to dodge to the side of the path to avoid being run down by a scooter or donkey cart. Not exactly my idea of chilled out and loungy.

Moroccan-inspired interiors became gypset in the 1970s, when *Vogue*'s editor in chief Diana Vreeland sent Patrick Lichfield to photograph the druggy, fabulously rich "it" couple John Paul Jr. and Talitha Getty at their Palais de la Zahia, or as their friends affectionately called it, "The Pleasure Palace." Talitha posed on the carpet-strewn rooftop in expensive jewels and a brocaded caftan. The chambers of the palazzo showcased the interior's equivalent of Dior's New Look: ethnic horizontal living with party-sized day beds all arranged for a chic jet set decadence. When the issue hit the newsstands in January 1970, it caused a sensation. Designers from Yves Saint Laurent to Zandra Rhodes began turning out embroidered tunics and harem pants. Continental formality was instantly outdated.

Of course, things in Marrakech have changed since then. By decree of the cosmopolitan King Muhammad VI, the city has been revamped. Newly minted resorts line the freshly paved

A patchwork streetscape in Marrakech.

boulevards beyond the Medina. They crowd around the new Berber Museum, featuring Yves Saint Laurent's private collection of art, textiles, and antiquities. Out in the Palmeraie, the palm-grove outskirts, there are enormous fortress-like compounds with honeycomb vaulting and giant domes belonging to Arab sheiks and wealthy arrivistes, like the international intelligentsia who jet in for The Marrakech International Film Festival every fall. It's over the top.

And the post-Getty Marrakech is still turning out a singular brand of bohemian style. Only this time around, it's less expat luxe and more about cross-cultural pop. Mixing local tradition with international influences comes naturally to a polyglot country that has been conquered at various times throughout its long history by the Arabs, Africans, Ottomans, and French—not to mention the Gettys, their fashion friends, and the planeloads of interior designers that followed.

Case in point is the Riad El Fenn opened by Vanessa Branson (Sir Richard's sister) about a decade ago. The El Fenn is one of the first hotel conversions in the ancient Medina. (Riad is the name for a courtyard home, often several centuries old, with leafy gardens.) The El Fenn, a chic labyrinth of dipping pools, passageways, and tangled vines, has none of the maximalist opulence of the Gettys' palazzo. Rather, it's done up casually in a retro 1960s palate. The Gettys's Pleasure Palace was designed by Bill Willis, who specialized in Islamic-themed fantasias for the uber-weathly: Yves Saint Laurent and Baroness Guy de Rothschild were clients, for example. But Branson's El Fenn takes its design cues from popular culture: Warhol red walls, *Mad Men,* Tiffany-

Above: A collection of slippers at the entrance of Riad El Fenn.
Opposite: A whimsical daybed in the courtyard of the hotel owned by Vanessa Branson.

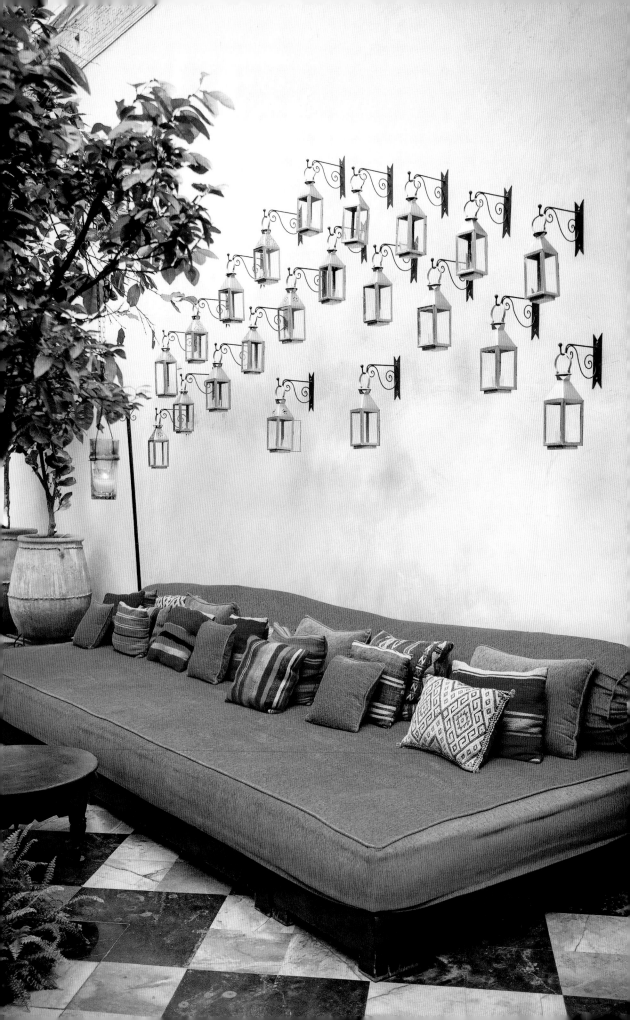

blue velvets, acid house black-and-white tiles. And it works: El Fenn is the inn of choice for design pilgrims—something I discover while having mint tea one afternoon. There on the rustic rooftop terrace, I run into two interior designer friends from New York City among a cluster of spare banquettes covered in earthy striped blankets underneath woolen Berber tents. The designers agree: "Sometimes knowing when to stop is a talent in itself," one comments.

Like everything else in Marrakech, finding the authentic, gypset scene requires introductions, connections, and peeking behind closed fortresses. Inside the ancient walls of the Kasbah is a fresh influx of artists, musicians, and fashion designers from Casablanca to California who are setting up their contemporary versions of a pleasure palace.

The Moroccan-born artist Hassan Hajjaj has such a riad. When I arrive, he's in the courtyard manning his computer, readying an exhibition for The Los Angeles County Museum of Art. His pop photographs line the tiled walls and picture locals dressed up in ghetto fabulous Moroccan get ups, a mash of traditional textiles and international luxury brands that Hassan designs himself. (I recognize his photos from the impeccable dining room at the Riad El Fenn.)

Hassan tells me his riad was a hotel for a while, but he got sick of dealing with demanding travelers and now it's a gallery/studio and a guesthouse for friends. And really, there's no better luxury than having an entire riad for oneself and an entourage. The garden is furnished in a way Talitha Getty would have never dreamed up: Eero Saarinen tulip chairs and plastic Coca-Cola crates with fake Louis Vuitton branded cushions. Next, he takes me up to the roof deck. It's a private gym with a punching bag, bench press, and barbells made out of brightly colored Moroccan food packaging—a spoof of both machismo and Warhol's *Campbell Soup Cans*.

Hassan's best friend, muse, and neighbor is the Moroccan-French pop star Hindi Zahra. She grew up between Paris and the small town of Khouribga, in the foothills of the Atlas Mountains. Like Hassan, Hindi remixes heritage Moroccan and Western pop culture. Her songs are a patchwork of Berber language, Ganoua bass, and gypsy guitar riffs. Her style is both Grace Jones and the Magreb: she pairs fez hats and velvet tuxedos. She's very gypset, and thus very hard to track down. Yesterday she was in Essaouira riding camels. Today she's back in Paris for fashion week.

In the afternoons, the neo-boho art crowd can be found in the oasis-like gardens of Le Jardin, a café in a seventeenth-century building in the middle of the Medina. Algerian designer Nyora Nemiche is parading around in her abaya caftans that she sells in her pop-up shop above the café. The rapper Mos Def is hanging out on the balcony, flipping through magazines. (He apparently lives in Marrakech part-time.) And sipping watermelon juice with me is Laila Hida, a thirty-year-old photographer/activist from Casablanca, who is a sort of catalyst of the new Marrakech art scene.

Seating area vignette, Riad El Fenn.
Following pages (left): Vanity area with skis at the medina home of fashion designer Artsi Ifrach.
Right: Marrakech's art crowd hangs out among the cool green-tiled courtyard at the restaurant El Jardin.

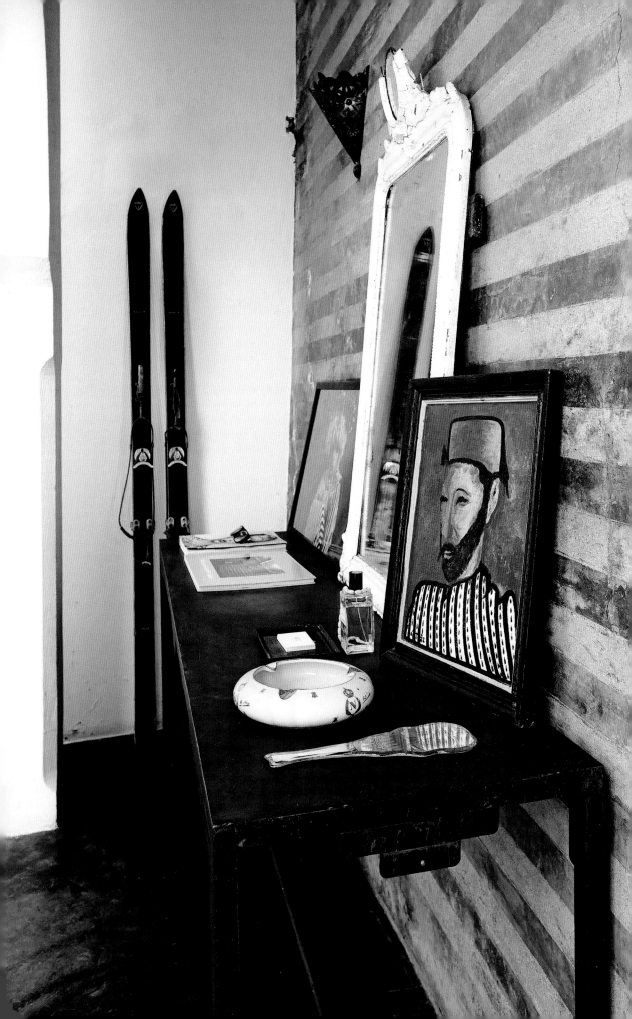

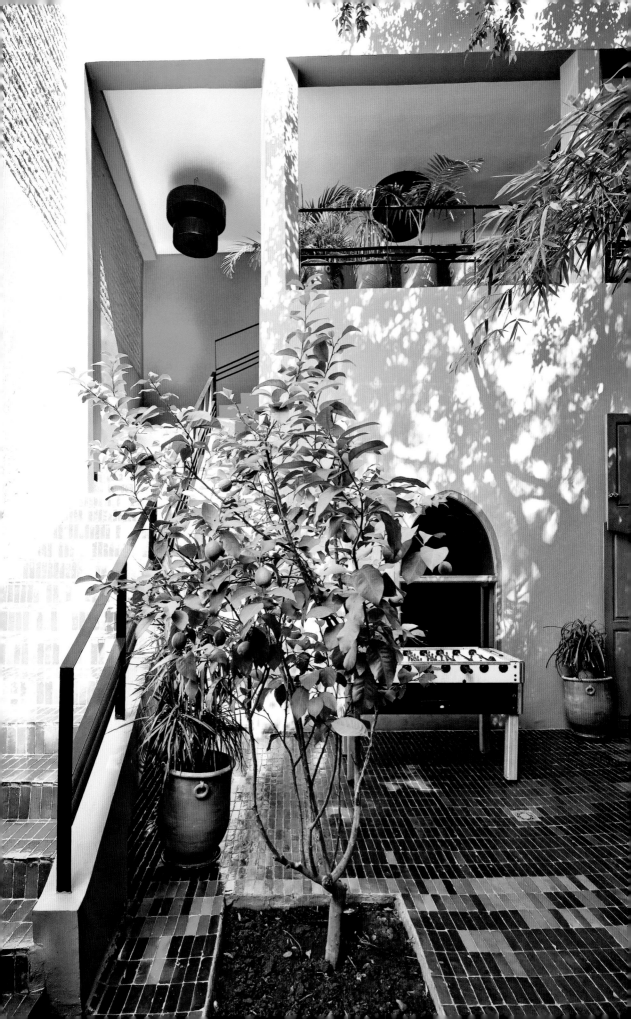

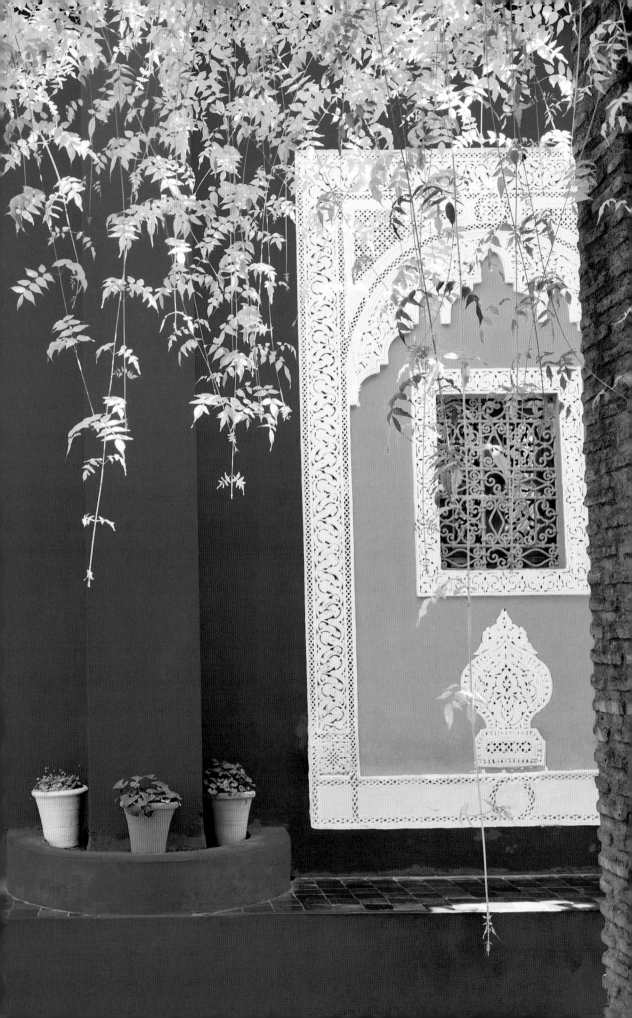

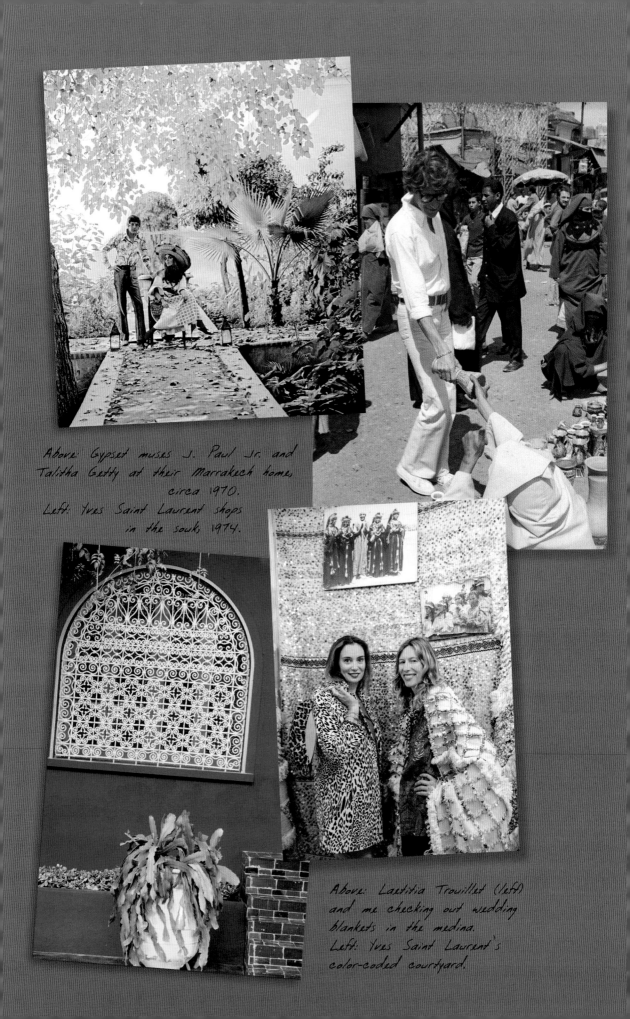

Above: Gypset muses J. Paul Jr. and
Talitha Getty at their Marrakech home,
circa 1970.
Left: Yves Saint Laurent shops
in the souk, 1974.

Above: Laetitia Trouillet (left)
and me checking out wedding
blankets in the medina.
Left: Yves Saint Laurent's
color-coded courtyard.

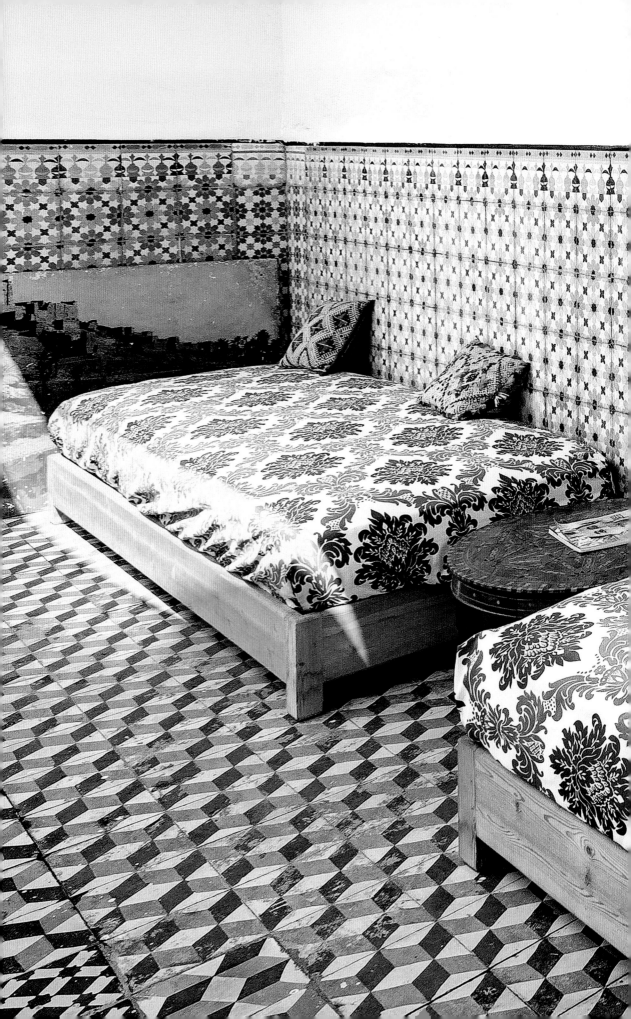

"Young people used to leave for university and not come back," Laila tells me. She herself went to the Sorbonne in Paris. "But now they are returning home and mixing new ideas with Moroccan culture and traditions. There's a feeling of collaboration here." In her skinny jeans and a droopy headscarf, Laila reminds me of a 1960s beatnik, but she's no dharma bum: she recently opened an arts center and hotel in an old riad called Le 18. "We're having an exhibition there tonight," she says, "you'll find the scene you are looking for."

Of course, I get lost trying to find the nondescript wooden door that looks like all the others on the quiet street. But inside, young Marrakechis are crowding around a courtyard to watch a dance performance. The decor is North African meets Brooklyn loft, with souk staples—beni ourain rugs, leather poufs, and framed portraits of King Mohammad—re-contextualized by the spare, gallery-like space.

Upstairs on the terrace a couscous dinner is being served around a long table. There, I meet Artsi Ifrach, better known as Art/C, an Israeli-Moroccan man in a white djellaba and tattoos. He says he was a ballet dancer in Israel and janitor in Amsterdam before moving to Marrakech five years ago to start his career as a fashion designer. "It's so isolated from the modern world here," said Artsi. "So you can experiment with your way of creating."

At the other end of the table are five Japanese guys, guests at the hotel, who are in a stoner-jam band and touring North Africa in a small camper. When the dinner ends after midnight, a few of us pile into a tiny 1960s Fiat belonging to an artist originally from Los Angeles and peel around the empty boulevards of the new city. We zoom past old fortresses and mosques with scratchy jazz playing on the radio, like a rickety time capsule in outer space shuttling a group of tipsy nomads.

The indigenous ethnic people of North Africa were the original nomads around here. They call themselves "Amazigh," which loosely translated means "Free People," but most know them as Berbers. Tribes of pastoral herders, they roamed seasonally from place to place, long before the jet setters and artists caught on. "You'd strap your stuff onto camels and horses, and away you'd go," explains Maryam Montague, the Iranian-American author of *Marrakesh By Design*. Montague lives in the Palmeraie with an encyclopedic collection of objects from tribal groups the world over. All nomadic cultures, whether they are in Pakistan, Mali, or Morocco, have the same essential packing list. "Carpets and cushions were so much more practical than furniture. So you'd set up your tent, roll out your carpets and everyone would lounge on the ground," explains Montague. "Slippers are important, so you can take off your shoes when you enter a home. It's important to keep the home clean, especially with all that lounging on the ground." To a gypsetter, the nomad way seems more relevant today than the Getty-era palazzo pomp.

Previous pages (left): Chaotic harmony: Moroccan mixed-and-mashed textiles.
Right: Patterned tiles and bedspreads at the art center/hotel Le 18.

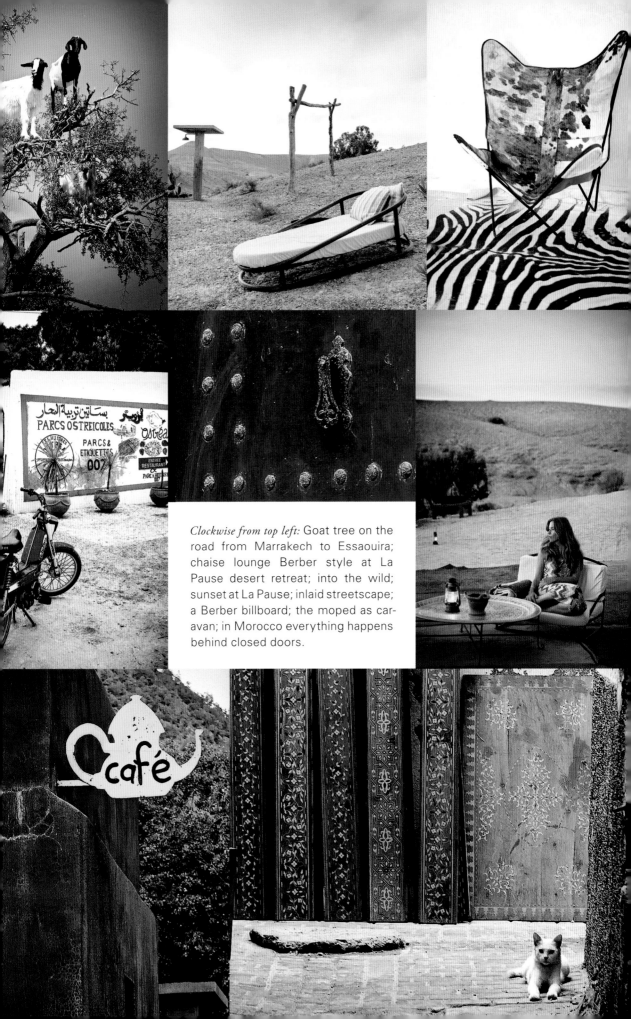

Clockwise from top left: Goat tree on the road from Marrakech to Essaouira; chaise lounge Berber style at La Pause desert retreat; into the wild; sunset at La Pause; inlaid streetscape; a Berber billboard; the moped as caravan; in Morocco everything happens behind closed doors.

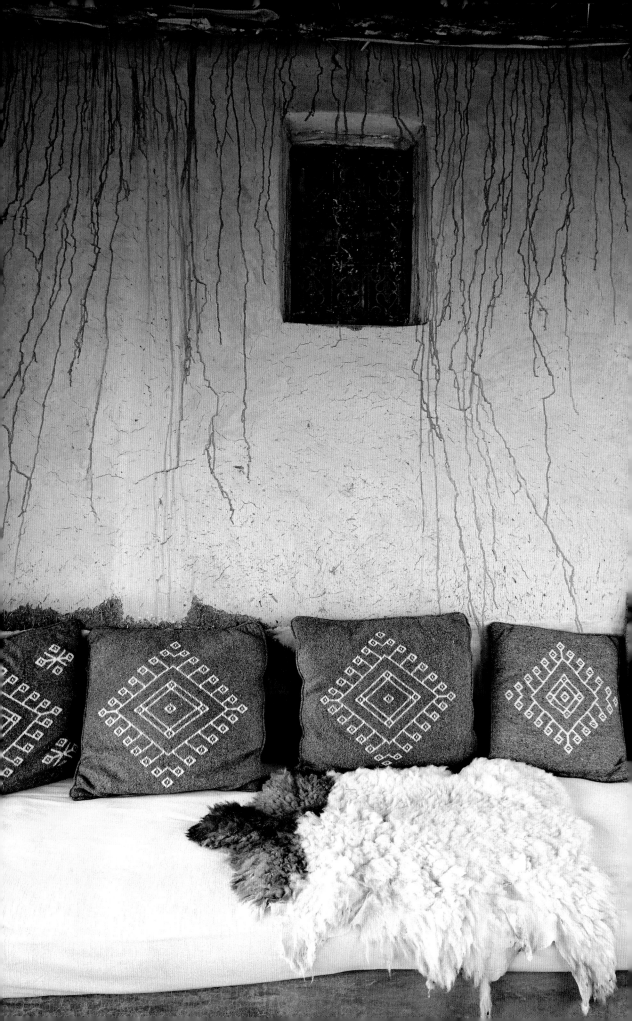

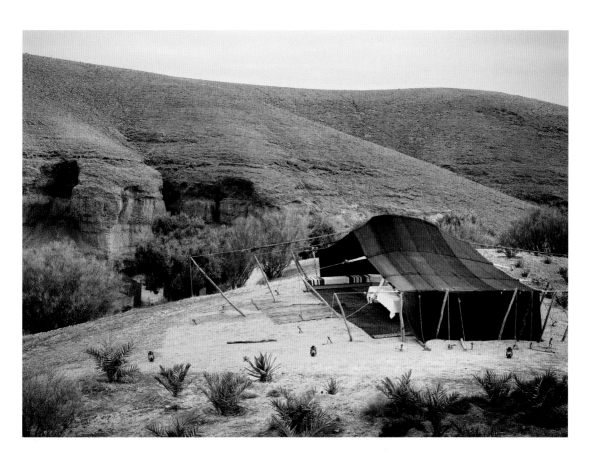

Most of Morocco's nomadic Berber tribes are based deep in the Sahara or high in the Atlas Mountains, where sheep are abundant and women weave the highly coveted carpets out of the thick wool. But about an hour outside of Marrakech, I find the Berber style (as interpreted by a French photographer) beautifully turned out at La Pause, a rustic eco-friendly oasis nestled in the arid countryside. Frederic Alaime has the vibe down. There are guest huts made of thick pisé (straw and mud) and furnished with luxe portables like silver trays and hammered brass lanterns. Bedouin tents made of wind-resistant brown camel hair and furnished with red wool rugs and cushions are set up to capture the views. At night, flickering torches and constellations light up the whole place. The Getty Palace it's not: La Pause taps into the ancient nomad roots of the gypset lifestyle, uncut and unadulterated. I'm so inspired that I rush back to the souk and stock up on such Berber staples as carpets, lanterns, and cushions to ship back to my home in Brooklyn, New York. Now I understand Morocco's monopoly on the exotic, sexy, and bohemian.

Right: The Berber palette: earthy tones, mud-and-straw walls, and animal pelts.
Above: A Berber tent at La Puase.

Island Laze

HYDRA, GREECE

Gypset Rule #4: In the Mediterranean, everything from swimming to soul searching should be done with an entourage.

I'm interested in where civilization went wrong," the American painter Brice Marden told me at the Pirate Bar, an artists' hangout on the island of Hydra, Greece. "For me its more about ancient culture and myth." It's mid-morning on the busy horseshoe-shaped port with ferries puttering in from Athens, donkeys with carnations tucked behind their ears, and human-pulled trolleys hauling luggage up the winding cobblestone streets. People are beginning to stumble down the hill from homes and hotels, like supplicants, to get their jolt of rocket-fuel-strength caffé Freddo: iced cappuccino topped with thick, sweet, addictive foam.

The terrace of the Pirate Bar looks like all the others here: closely packed lines of tables shaded from the hot Mediterranean glare under well-kept awnings. But it's actually the meeting place of the island's bohemian scene, where artists gather for snacks and sunset cocktails and often stay on until late into the summer night. If you're looking for Juergen Teller, the German photographer and his gallerist wife Sadie Coles, or perhaps Italian conceptual artist Maurizio Cattelan, or Swiss sculptor Urs Fischer, they're here. They usually wander in at some point late in the day with note pads, computers, and lo-fi Lomo cameras stuffed into their beach bags.

"I get a lot of work done here. I like the light, the pace," said Brice who, with his wife Helen, bought a home on Hydra in 1973. Since then he has produced several series of paintings inspired by the island. Now the rest of the art world has caught up. Hydra has been a must-stop at least since 2009, the year that Greek Cypriot collector Dakis Joannou opened the art space Slaughterhouse.

Urs Fischer's sculpture for the DESTE Foundation's Slaughterhouse on the island of Hydra.

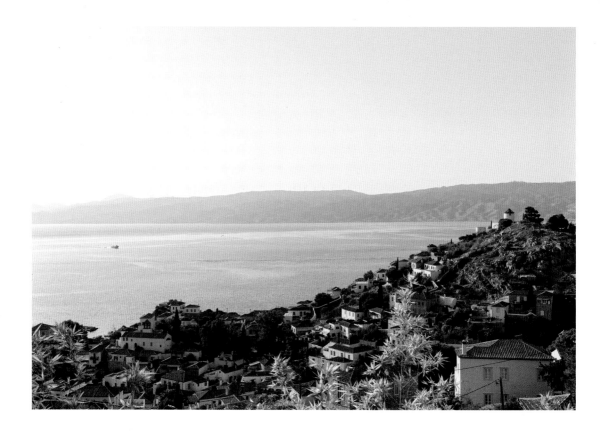

A stone bunker perched on a craggy cliff above the Saronic Gulf, it used to be just that. Cow hooks remain in the concrete floor along with holes where animal blood would drain into the sea below. "It's meant to be a juxtaposition of primitive and sophisticated," Dakis told me. "Like the island itself."

Every June, Dakis, a patron of the gypset in the tradition of Peggy Guggenheim or Sir Edward James, invites an artist to interpret his Slaughterhouse (past participants have included Mathew Barney and Urs Fischer). Then he imports his friends, and friends of friends, for a weekend-long opening fete. A lucky few arrive aboard his yacht, *Guilty,* decorated by the artist Jeff Koons to look like a floating neon cubist cartoon. It's *Miami Vice* by way of *Guernica.* "Hydra is not arty in the conventional way," explained Dakis, who has kept a house on the island since the 80s. "It's not Williamsburg with artists living on the cheap or the Hamptons with its crazy parties. It's a small-scale community kind of place; very friendly, with groups of people going out to the tavern to eat."

Tucked into the town are several world-class contemporary art spaces, found on the labyrinthine back streets or in repurposed commercial buildings. (Cars and motorbikes are banned on the island, so art pilgrims must make due with comfortable walking shoes.) In addition to the Slaughterhouse, there's the Hydra Workshop, a gallery run by the collector Pauline Karpidas in an old ship-repair garage of a mansion once belonging to the Bulgari family. And the Hydra School Projects, a pop-

Above: A view of Hydra and the Saronic Gulf.
Opposite: Mirabelle Marden's minimalist kitchen decorated with a single slab of blue Brazilian marble.
Following pages: Tribal Minimalist: The Marden's spare, low-lined living room.

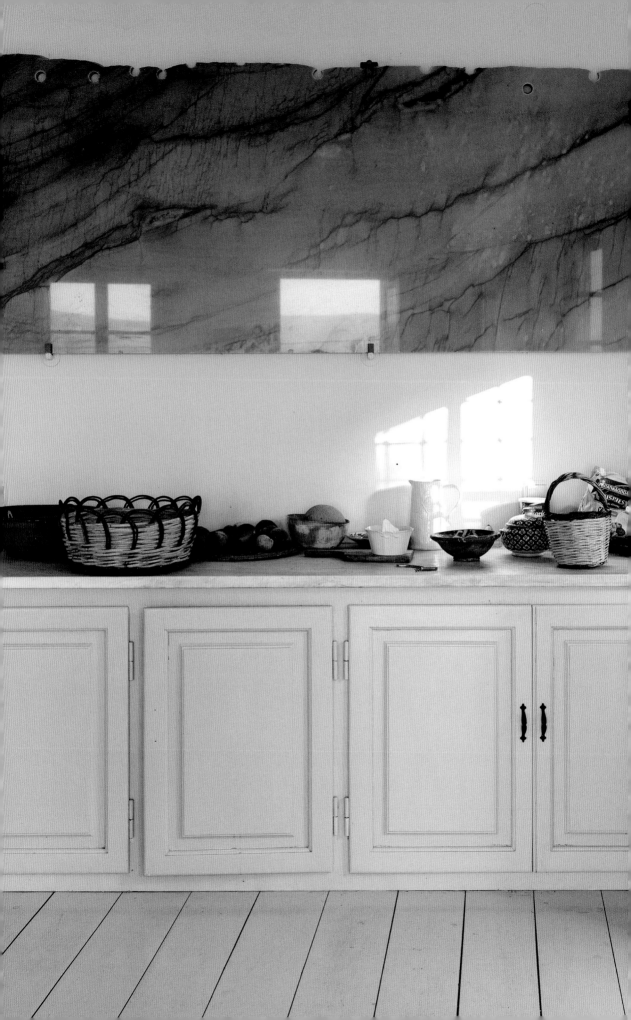

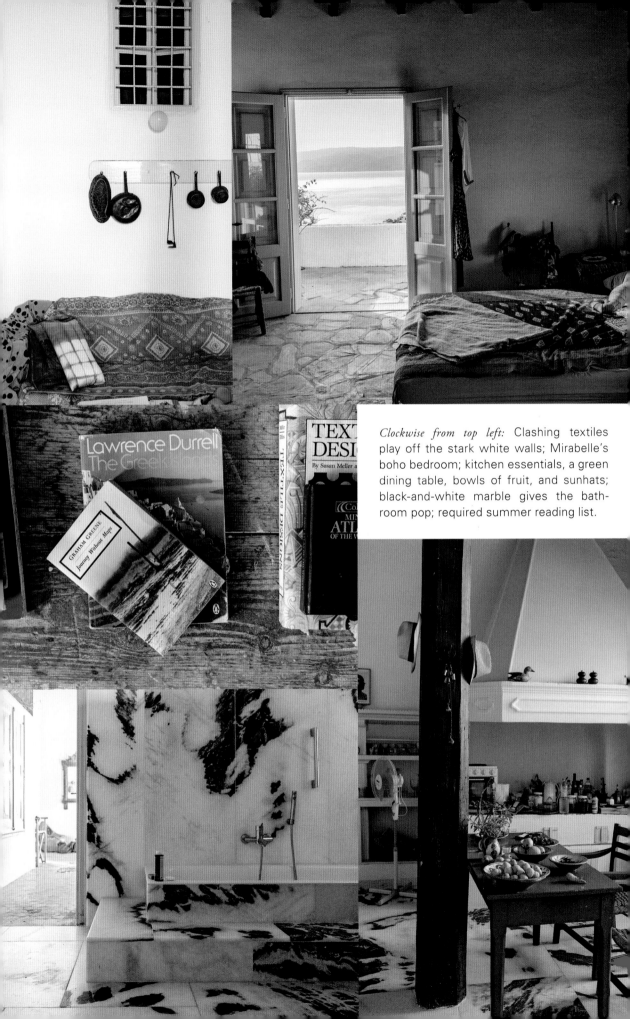

Clockwise from top left: Clashing textiles play off the stark white walls; Mirabelle's boho bedroom; kitchen essentials, a green dining table, bowls of fruit, and sunhats; black-and-white marble gives the bathroom pop; required summer reading list.

up in the local high school up in the hills, where I find Mark Borthwick, a Brooklyn-based artist, poet, and total gypsetter, on a recent afternoon inside one the classrooms turned exhibition spaces with photos of donkeys on the wall and the wafting aroma of incense. Mark, who has the earthy tan and spontaneous demeanor of a Seville street musician, was standing in a sarong and sneakers, strumming a guitar with his long, pick-like fingernails as part of an installation for his film *Poet Tree* that would screen at an open-air theater nearby.

Long before the galleries and wealthy collectors, though, Hydra was a refuge for artists and intellectuals. The writers Henry Miller and Lawrence Durrell came to stay with the painter Nikos Hadjikyriakos-Ghikas at his family's mansion in the late 1930s, inspiring a chapter in Miller's travel book *The Colossus of Maroussi*. "There are only two colors, blue and white, and the white is whitewashed every day, down to the cobblestones in the street," Miller wrote. "The houses are even more cubistically arranged than at Poros. Aesthetically it is perfect, the very epitome of that flawless anarchy which supersedes, because it includes and goes beyond all the formal arrangements of the imagination."

The singer and songwriter Leonard Cohen, at the height of his fame in the 1960s, traded the dreary London fog for Hydra and bought an old whitewashed building with no electricity or running water. "I will do a little work on it every year and in a few years it will be a mansion..." Cohen pledged in a letter to his mother. A wave of creative acolytes followed him: poets, artists, and musicians, who thronged the open-air tavernas at night and shacked up in the decrepit stone buildings.

"I remember going to a costume party and getting totally lost," said Brice of the Cohen era. "There were a lot of characters here. Any traveler with a private income could buy a house for $700. Or you could win one in a card game." What you get for your money on Hydra, just an hour and a half by Hydrofoil from Athens, is much grander than the architecture of most of the other Hellenic islands. In the eighteenth century, Hydra was filled with wealthy merchants, admirals, and sea captains who built mini stone palazzos in the Venetian style with French and English antiques, which now flank the hills around the port like stately vintage courtesans.

The Mardens live in such a house, a pristine example of the minimal Greek island style. Actually, it's more of a family compound with two houses. One for Brice and Helen, and another for their daughters Melia and Mirabelle. All based in New York City, Melia is a chef specializing in easy, Mediterranean-inspired fare. Mirabelle is a fine art photographer who travels for work and inspiration to places like Cornwall, Montauk, and Kauai—outposts on the gypset trail. Helen is a painter and interior designer responsible for much of the boho flair of the compound. It's sparsely furnished with a few local antiques. Each chair has a perfect vantage of the sea and horizon. In order

Following pages: Mirabelle Marden's living room. The sleeping dog is actually a sculpture purchased at the contemporary art summer pop-up, Hydra School Projects.

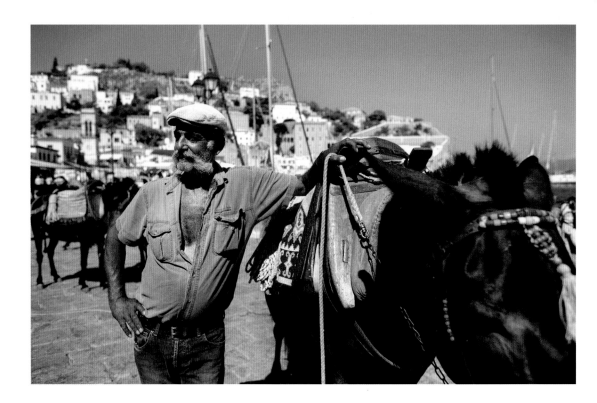

not to distract from the soft Mediterranean light and the harsh rocky landscape that Helen calls "so powerful and beautiful," the walls are intentionally bare—save for a slab of Brazilian blue marble that Helen put up above the counter in Mirabelle's kitchen. Arguably the best seat in the house is a rickety lounger in the garden, shaded by rosemary shrubs, jasmine vines, and olive trees.

There's little reason to leave this personal utopia, except perhaps to take an afternoon dip in the silky sea. The Mardens favor Limioniza, a secluded beach on the uninhabited south side of the island accessible by water taxi. Nature excursions and treks to hillside monasteries, seaside villages, and remote beaches are something of a ritualistic pastime on Hydra and nearly always a group effort. In the Mediterranean, everything—from swimming to soul searching—is done with an entourage.

When the sun sets, the flurry moves on to the tavernas with clusters of outdoor tables and guitar players crooning traditional ballads—like at Gitoniko, run by a local couple, Christina and Manolis, serving up fresh eggplant salad; grape leaves stuffed with raisins, pine nuts and cinnamon; and grilled calamari caught just offshore. Afterward, everyone migrates back to the Pirate Bar for another carafe of wine. And that's where I run into the Los Angeles-based artist Doug Aitken, who happens to be on Hydra to install his project for Slaughterhouse. He sums up the gypset mood of Hydra perfectly: "There's a kind of slowness here," he mused. "You just kind of step off the world."

Above: Donkeys are so much cuter than cars.

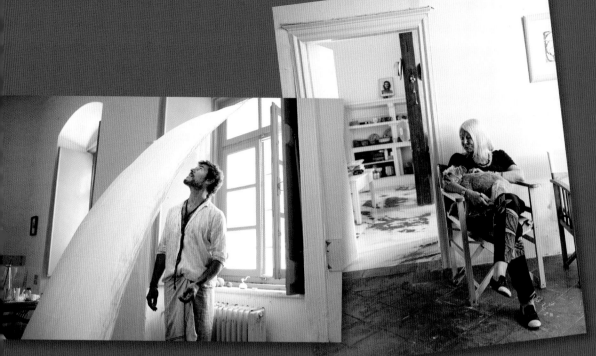

Above: Artist Mark Borthwick readying his
installation at the Hydra School Projects.
Upper right: Helen Marden relaxes.

Above: Hydra is filled with
tavernas serving traditional
Greek dishes. Left: Hydra's
main swimming spot.

Above: Daytime at the Pirate Bar.

Above: An evening serenade.

Decadent Dreamscape

CUIXMALA, MEXICO

*Gypset Rule #5: Villas, palazzos, and mansions are fine
as long as you share them.*

When Alix Goldsmith Marcaccini wanted me to come to Kosmosis, her opulent end-of-the-Mayan-calendar celebration at her home in Mexico, she didn't bother to send a hardcopy invitation. Instead, I received several personal messages from her inner circle (via Facebook and Instagram—in the alternate Gypset universe, concrete addresses simply don't register). One such hinted invitation, and my favorite, was a 1970s YouTube video of Raquel Welch, dressed in a sun goddess gown, singing Age of Aquarius on the pyramids in Teotihuacan, Mexico. And then when I bumped into Alix's friends at an art fair in Miami, they doubled down; "Alix would love it if you came." It was more than a request. It was a call. I had to go.

So I flew from my home in New York City to Puerto Vallarta on Mexico's Pacific Coast and drove three hours south to Cuixmala, Alix's house (or, as she prefers to call it, hacienda). Partly run as an exclusive resort, it is a 2,000-acre estate crowned by a huge Moorish-style villa with an illuminated dome, painted up in gold and blue zigzags. Guarding the entrance are two bronze sculptures: a gorilla and a rhino. And when I arrive, via a five-mile driveway with a security escort, it is among the white arched and airy chambers of La Loma, as the villa is called, that I find Alix's other guests—just in from London, Ibiza, Topanga Canyon, and Mexico City—sprawled on big cushions covered in Indian fabric and working hard to deplete an endless supply of freshly mixed margaritas. Nobody seemed to know, or care too much, what was going on. "I think if you get hungry, you

Gatsby Moellhausen and Maxime Classen (seated) at Cuixmala's
Moorish-inspired palazzo, La Loma.

can knock on that door and someone will cook you something," one guest explained. "I saw them building a pyramid out of sand earlier today," reported another nonchalantly, from the hot tub.

Alix is a charismatic and generous host in the tradition of both heiress Barbara Hutton, with her lavish costume parties at her Tangier palazzo, and Burning Man, the experimental arts festival in Nevada's Black Rock Desert. Alix was no doubt influenced by her father Sir James Goldsmith, the late Anglo-French tycoon and billionaire who built Cuixmala in the 1980s as a retreat for him and his extended family of wives, mistresses, and children.

Sir Jimmy, as he was known, had a private jet tricked out in an Indian theme lined with silk, and would fly into Puerto Vallarta with an entourage which included Henry Kissinger and Ronald Reagan. Then they would hop a small propeller plane and touch down on Cuixmala's grass runway, which is still in use today especially for jaunts up to Hacienda de San Antonio, La Loma's grand sister property, an old coffee plantation in the mountains. Towards the end of his life, Sir Jimmy became distraught by apocalyptic woes, like pesticides, genetic engineering, and nuclear energy. So La Loma, designed by Frenchman Robert Couturier, was built with enough steel and concrete to withstand a bomb. An environmental activist, he bought up a 32,473-acre swath of land along Mexico's Pacific Coast Highway, much of it a rare dry tropical rainforest, and donated the majority of it to the Chamela-Cuixmala Biosphere Reserve, a foundation formed in cooperation with the

Above: Admiring La Loma from afar. *Opposite:* A stunning perch at Cuixmala.

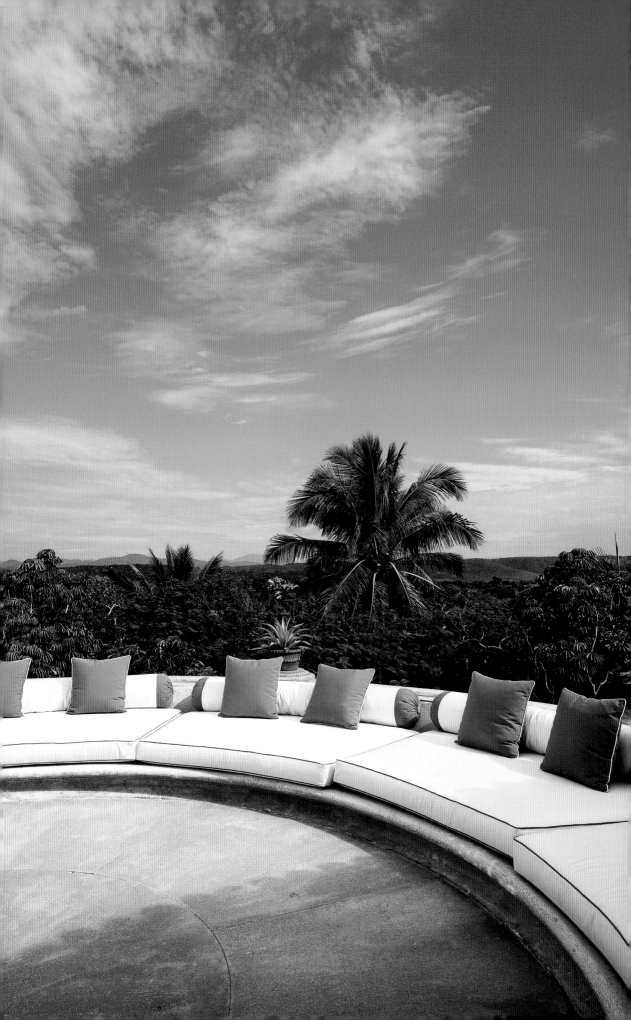

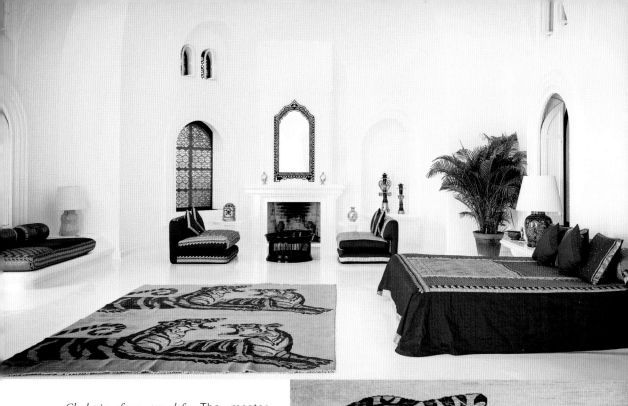

Clockwise from top left: The master bedroom at La Loma; Alix Goldsmith found the rug in a thrift shop in Aspen; crisp geometry and earth tones create a clean, airy feeling; the Indian textiles are from the markets of Varanasi. *Opposite:* La Loma's spacious chambers are a mix of Moorish, Indian, Mexican, and Mediterranean. *Following pages:* La Loma's built-in furniture gives the illusion of floating. Bold colored textiles and vegetation play off the high gloss white.

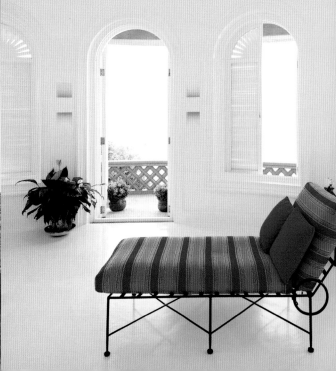

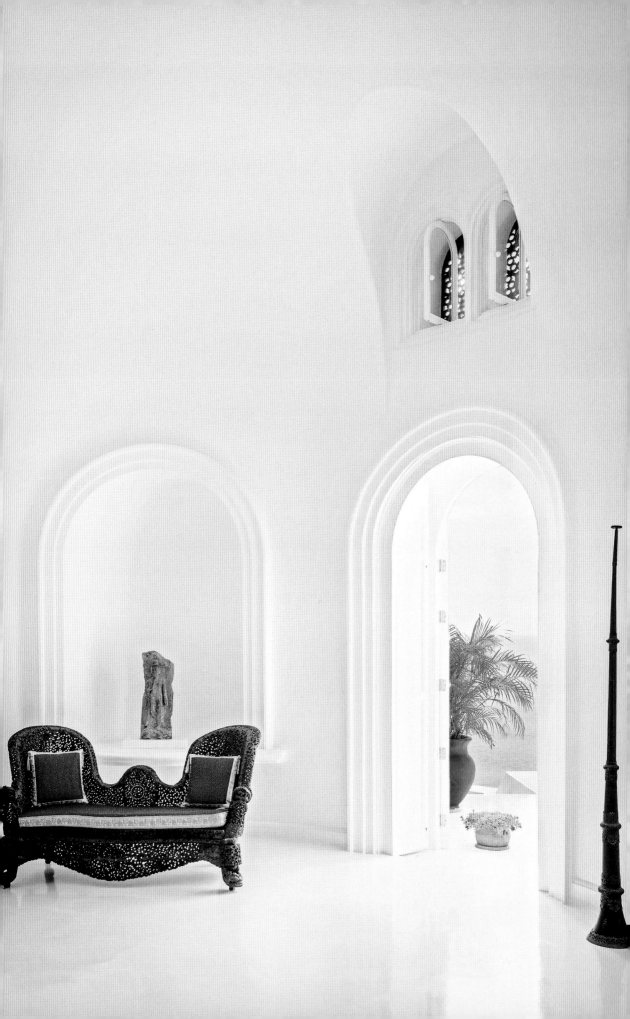

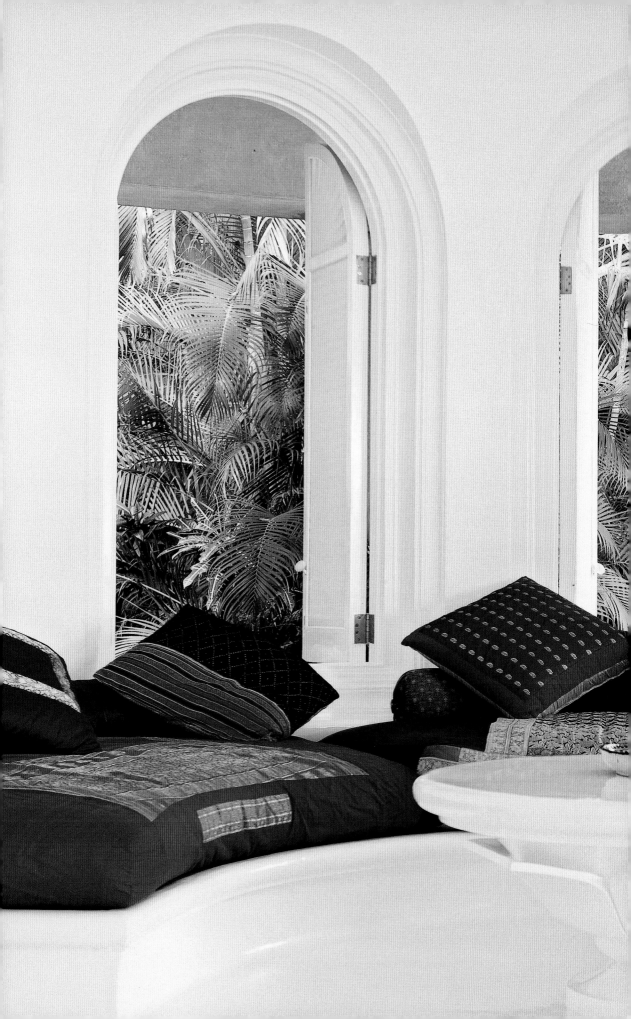

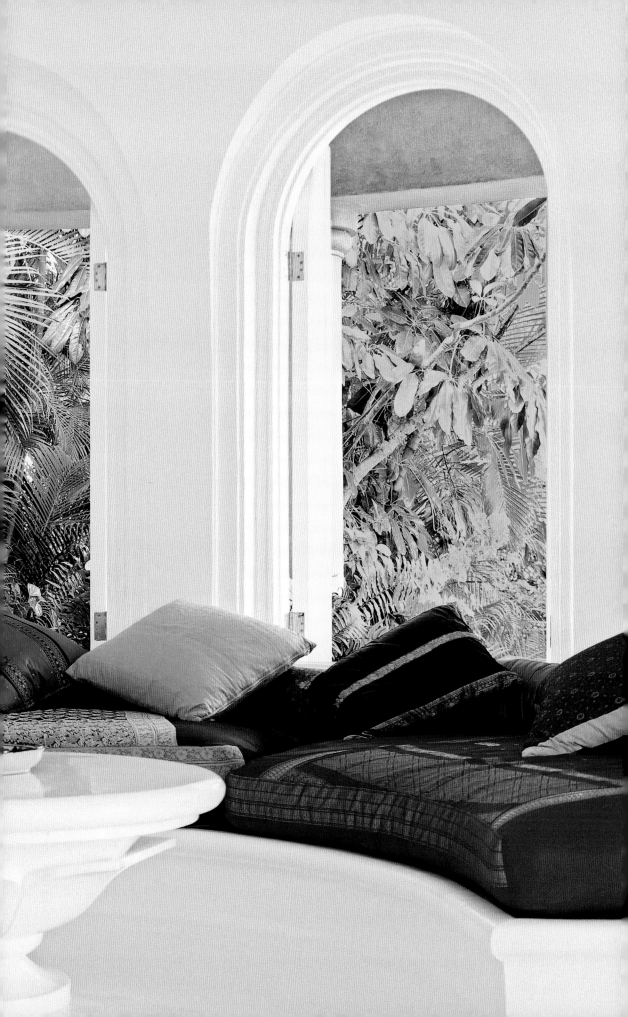

National University of Mexico. When the patriarch died in 1997, Alix and her husband Goffredo, living in Los Angeles, took over Cuixmala and transformed it into a luxury eco-resort utopia, with both a progressive conservation effort and an exclusive guest-list: Madonna and Mick Jagger among them. Hospitality apparently runs in the family—Alix's half-sister, Isabel Goldsmith, opened the boutique hotel Las Almandas an hour up the coast (Gypset-small-world-alert: Isabel was briefly married to the French playboy Arnaud de Rosnay featured in the Chapter 9, Maui.)

Alix's gatherings are legendary in gypset circles—and among tabloid ones, too. Guests to her New Year's Eve bashes have included Johnny Knoxville, Heidi Klum, and Alice Temperley. Kosmosis, held on the beach from sunset to sunrise, was even more bananas than I could imagine. Life-size replicas of the world's major pagan totems including Easter Island, King Pacal's gravestone, and Stonehenge were built on the sand and lit by hundreds of torches. When Alix appeared with her children in tow (Gaia, 20, Lea, 19, Sienna, 10, and Giacomo, 6) she was decked out in an Amazonian green-feathered headdress and a vintage Ossie Clark embroidered gown. "Events should be giving us creativity and inspiration, not just boring hangovers," she said approvingly.

Several hundred of us party guests—some who had hopped over from Careyes, another gypset community just up the road—mulled about in the balmy evening in tribal loincloth, Pocahontas minidresses, and turbans. We danced around bonfires and sand sculpted temples alongside local Huichol Indian musicians and shamans—pit stopping to chill out in teepees set up by the ocean. At some point I had the insane idea that swimming in the wild, turbulent sea would feel refreshing, until I noticed two lifeguards eyeing me from the shadows. Clearly, I wasn't the first drunken stray to tempt fate on this sandy shore.

When the sky began to lighten over the pyramids, I was ready to call it a night, but somehow on the way back to the elegant bungalow where Alix had me staying, I ended up in a field of wild zebras and elands, part of Cuixmala's animal preserve. I realize that after traveling to so many paradises ruined by development—Kuta, in Bali, and Mexico's Cabo San Lucas, to name just two—I'm struck by Cuixmala's true luxury. For miles in either direction there is hardly anything in the way of big cement developments and golf courses. It's pure deep-nature jungle and a rare treat for the senses. There are very few places in the developing world that are both close to an international airport and pristine. Local governments usually just sell out to the highest bidder. And in this area, luckily, that bidder was the Goldsmith family. Cuixmala was green before green became trendy. Organic gardens feed the guests and staff, gray water is treated and used for irrigation, and all the plants in the garden—from the bright marigolds and sunflowers to the spindly acacias—are drought-resistant native species.

Following pages: Guests at Kosmosis get tribal at a beach bonfire.
Pages 84–85: Cuixmala Coterie: Alix Goldsmith Marcaccini (seated center right, in blue tie-dyed caftan and medicine pouch) and Goffredo Marcaccini (back right, dressed in white with white hat) with their friends and family in front of their ranch-style home.

Scenes from the Kosmosis party. Stonehenge recreated on the beach.

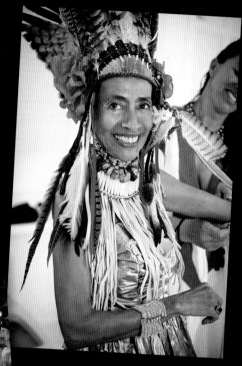

Above: quintessential barefoot chic.

Above: socialite-of-the-galaxy Ewva Anderson.

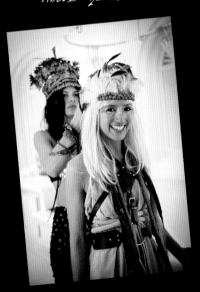

Above: gypsetter Hikari Yokoyama (front) and fashion designer Taiana Giefer dress for the party.

Above: A reveler pit stops in a teepee.

Right : Author Daniel Pinchbeck (left) with Philippe Moellhausen, who designed the Kosmosis event.

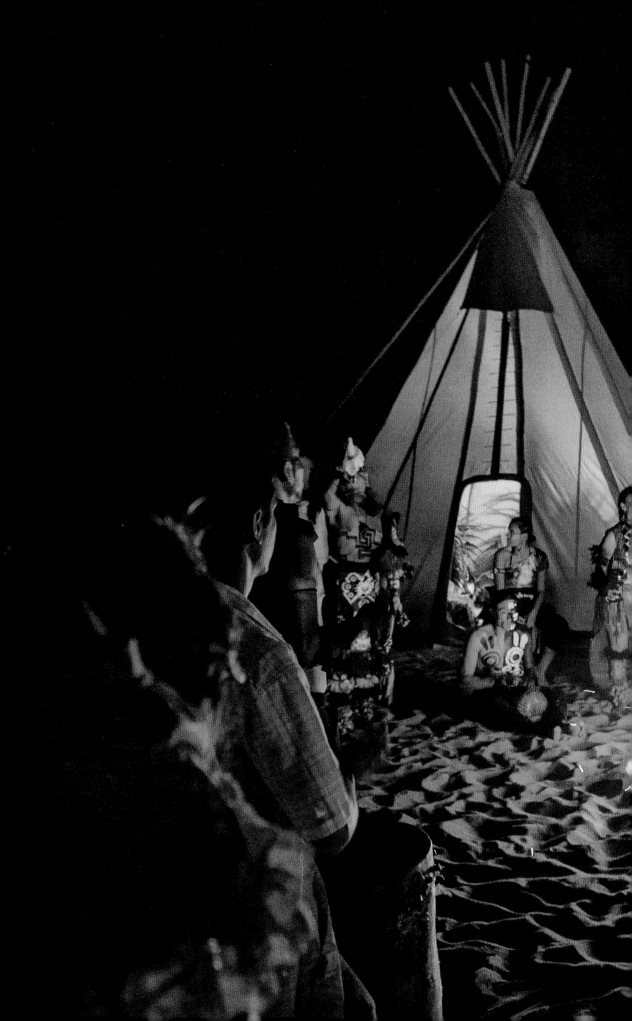

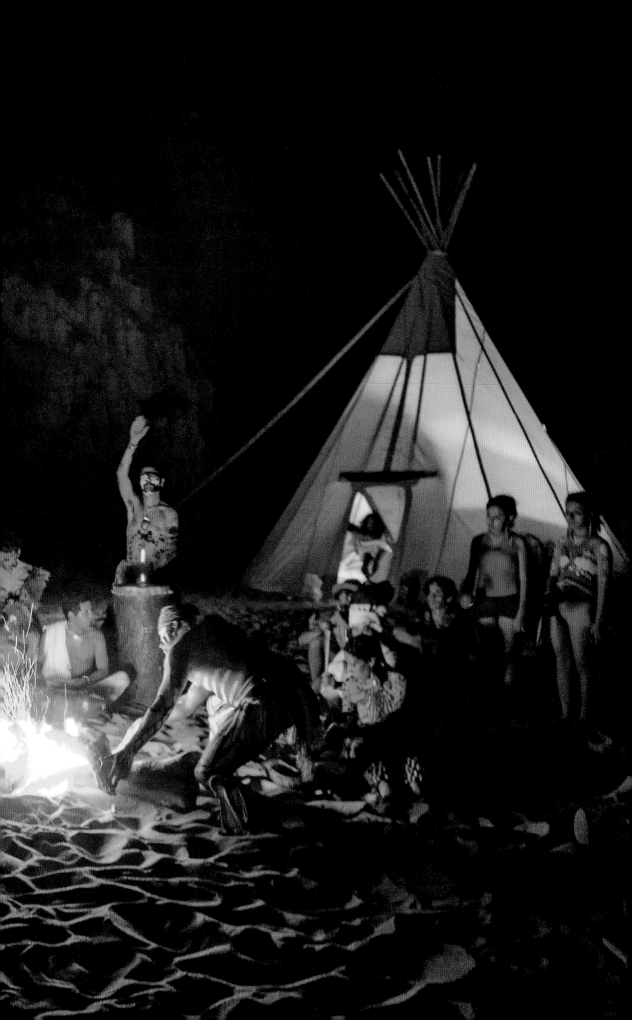

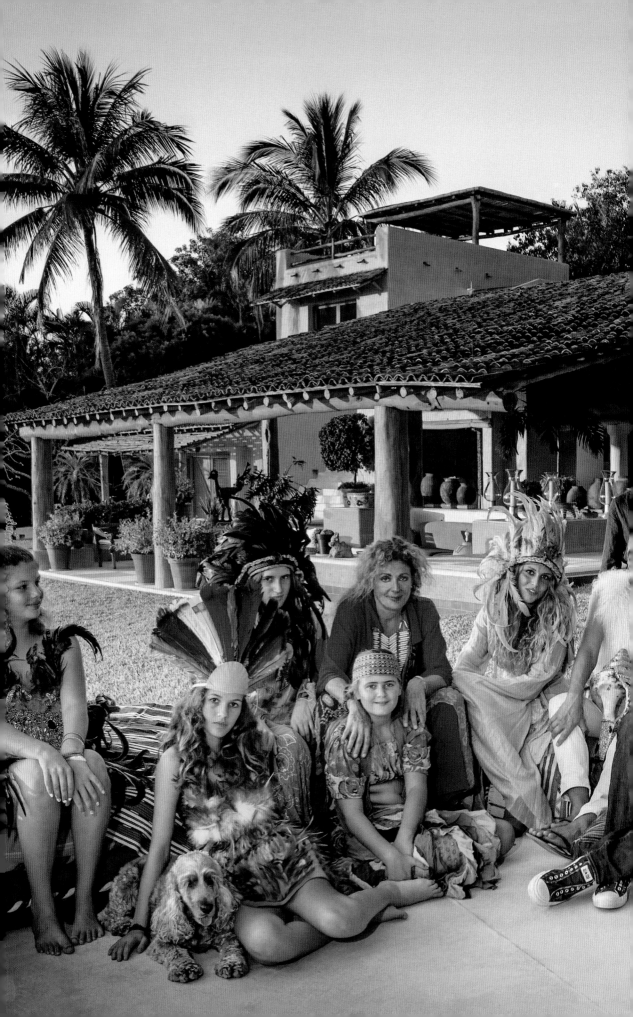

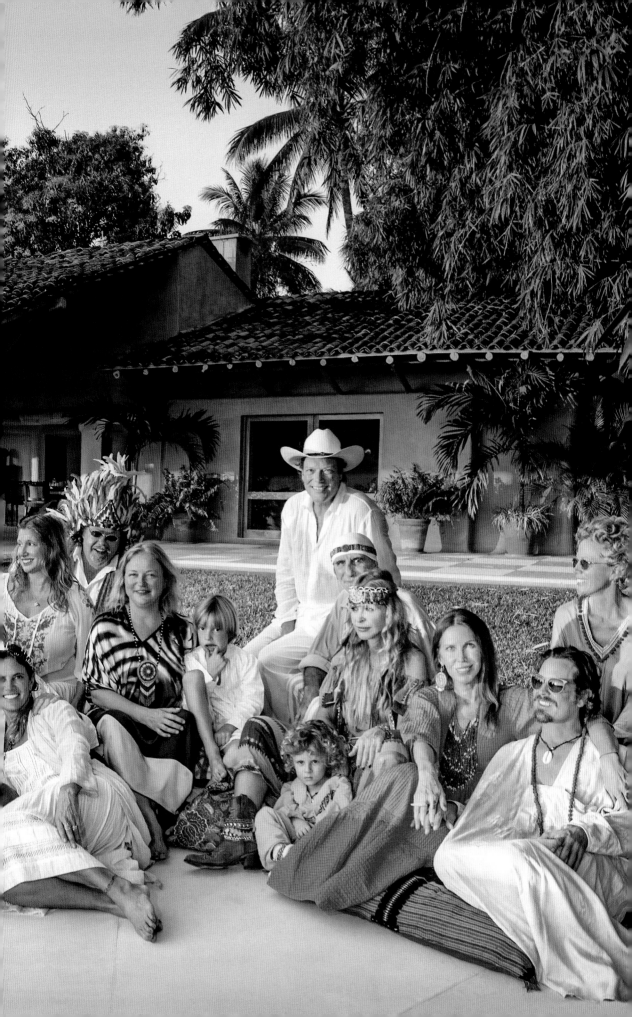

Alix and Goffredo are constantly flying in professors, specialists, and industry leaders for various permaculture and ecological seminars and workshops. "The idea is that you can do luxury and still not ruin the planet," says Alix, who has lately become obsessed with the farming techniques of Rudolph Steiner, the Austrian philosopher and social reformer. "It harks back to old Mayan and indigenous ways when farming was sacred. They made pesticides with bark and lined plantings up with moon cycles," says Alix, giggling in her infectious laugh when I point out that it sounds very Kosmosis-like. After all, a splashy party has always been a great way to win converts for your cause.

It's the evening after Kosmosis, and Alix and Goffredo are hosting a dinner for their fatigued guests. Compared to the general opulence of Cuixmala, their house is a more modest: a ranch style near the horse stables. It's decorated in a traveler's mish-mash from Alix's wanderings in Guatemala, Thailand, and Bhutan. A Mexican buffet of chocolate chicken mole, *chiles rellenos*, and *ensalada de nopal* has been arranged on a long farm table set with copper pots that Alix procured from a remote pueblo in Michoacán called Santa Clara del Cobre. "We went for the Day of the Dead, and you go all night on these little boats on a lake through islands in this massive lagoon," said Alix. The guests, some still sporting traces of tribal face paint on their cheeks from the night before, are crashed out on the day beds listening to a friend of Alix's daughter spin Mexican folk music. A few are trying to analyze the real meaning of the end of the Mayan calendar. One offers that Gian Franco Brignone, the eccentric octogenarian patriarch of the neighboring resort Careyes, is still hiding out in the mountains waiting for the big bang. Alix and I get into a discussion about Burning Man—par for the course in these scenarios. She went last year with her family and is totally hooked, especially by the festival's eco-mantra "Leave No Trace." After all, if you are as committed as she is to setting an eco-example by how you live, why not also by how you party?

Previous pages: Nature as sculpture.
Opposite: Way out of Africa. Trail rides in Cuixmala tend towards the exotic.

88

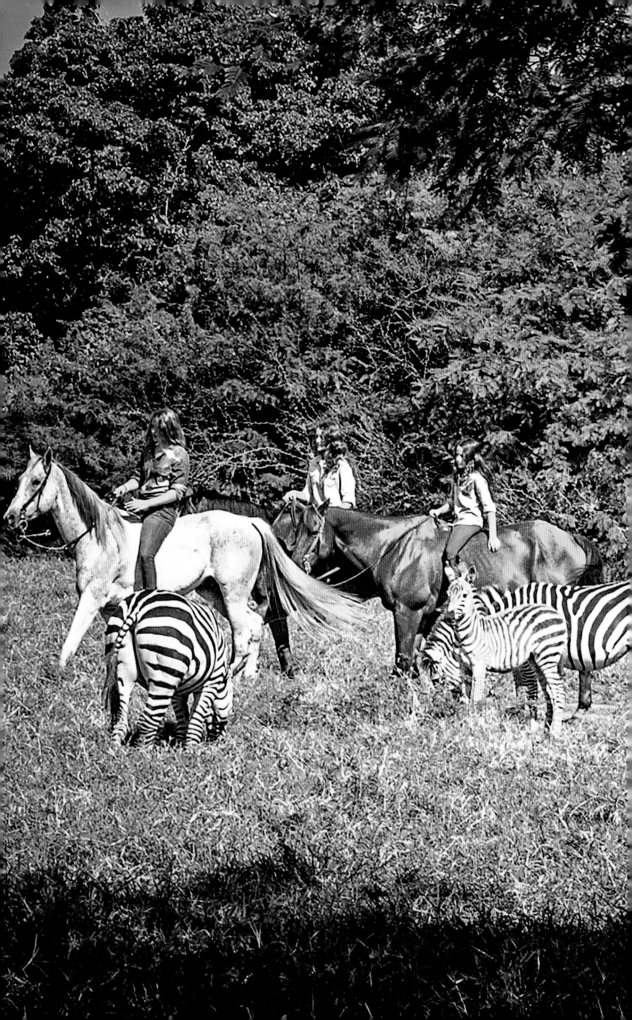

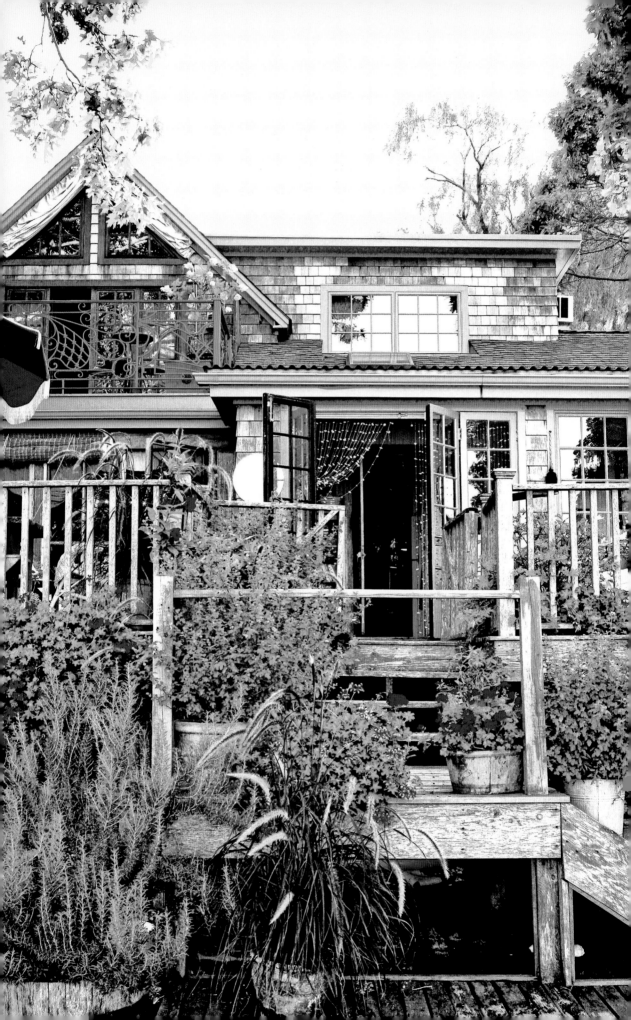

Summer Camp Luxe

THE SPRINGS, USA

Gypset Rule #6: Never crash a party empty-handed.

started my career crashing swimming pools as a kid living in Key West, Florida. Every day after school, my friends and I would hop on our bicycles and race down to the strip for a cool dip in a hotel pool. During my teen years, I took my talent international, to the south of France where I'd strip down to my bikini on the public beach, stash my shoes in the rocks, and swim around the corner to the exclusive Monte Carlo Beach Club. And today, even if I'm on the guest list, I prefer to hop a fence just for sport. Without my skills as a crasher, I could never have become a gypsetter. Crashing a party is like diving into the deep end of a pool—they're both about total immersion. It's a surefire way to meet new people, because you have to: it's sink or swim. The trick is to show up in costume (be it black tie or a bikini) and act like you belong.

It's a sticky summer night in the Springs, a hamlet of East Hampton, New York, and true to rule numero uno, I have two bottles of rosé, one in each hand. I'm dropped off at the far edge of a sprawling property. After wandering around a bit, I find a big converted barn and flame-heated hot tub—but no party. Then a clue: A golf cart stuffed with revelers in safari hats and maharaja turbans whizzes past. I follow it. Soon, I can see a torchlit stage in the distance. Finally, I reach the bluff overlooking Gardiner's Bay, where a crowd is watching a ragtag group of actors reciting Shakespeare in togas, garlands, and high-top sneakers. In the nearby woods, dozens of tents and yurts are set up like some kind of boutique Wes Anderson Woodstock. Guests are drinking tequila-spiked sassafras ginger punch. Some have been camped out all weekend and are now pairing off towards the beach

Lorraine Kirke's boho home in The Springs.
Following pages: Clashing textiles, painted floors and ceilings, and fishing net scrims groovify the screened porch.

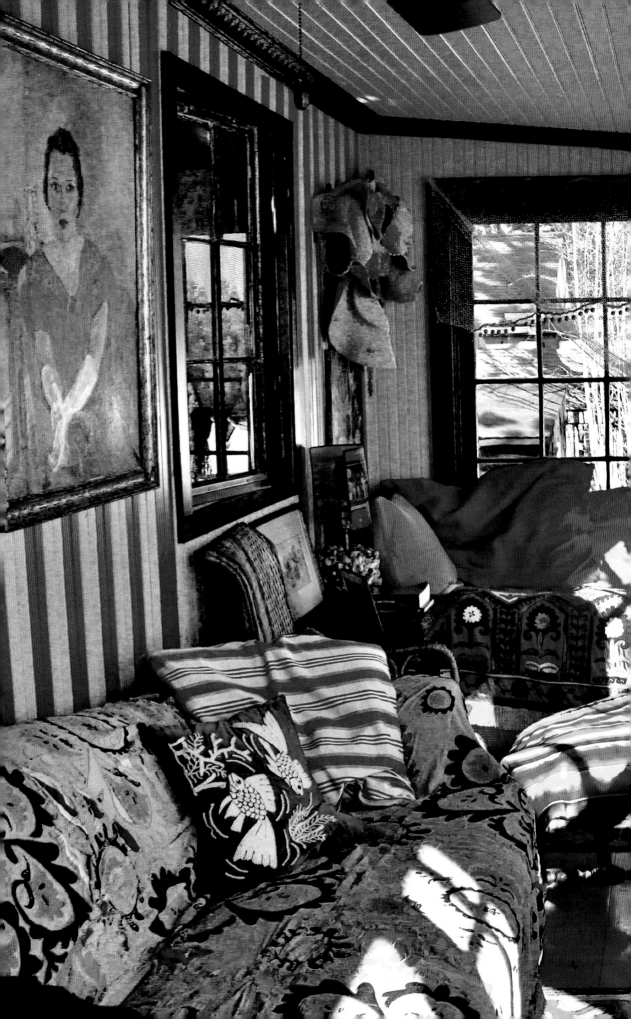

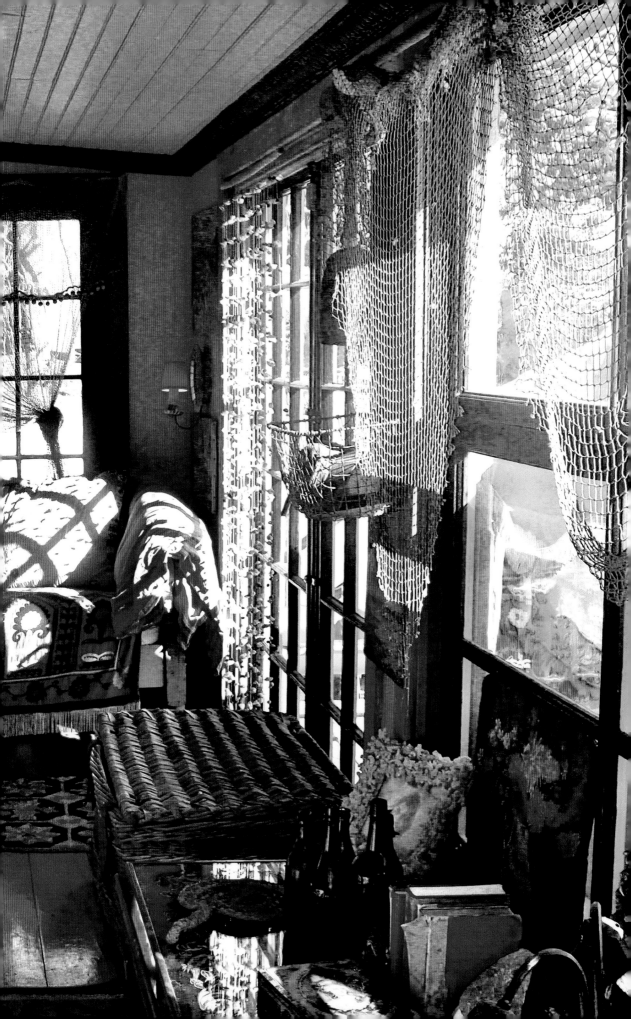

for midnight swims. I can't really tell if people are in costumes or if it is their everyday look, which only adds to the mystery and the feeling that anything is possible—at least until the sun comes up.

Eventually the party moves back to the barn, or as the natives call it, "Barnonia." The wooden floor has been painted an electric shade of fuchsia. People are mixing more drinks from dusty liquor bottles atop an antique stove. And behind a makeshift recording studio of keyboards and an old set of turntables, someone has begun to DJ. A full dance party is soon underway with revelers grabbing party props hanging on nails—an old life buoy, wooden tennis rackets, and Robinson Crusoe straw hats. By about 4 a.m., I'm getting sleepy and my ride has disappeared—I suspect into one of the yurts—and so I climb up to the communal hay loft and doze off on a yoga mat while listening to a lone straggler play The Rolling Stones's "Let It Bleed" on the keyboard. Or at least that's the last song I remember.

To understand the gypset charm of The Barn, you have to understand where it is. It's located just a few miles from the Hamptons, that wealthy summer playground of rolling potato fields turned into gaudy mansions with manicured lawns, media rooms, central air conditioning, and sponsored parties: wealth and taste run amok.

"I loathe the Hamptons," said interior designer Lorraine Kirke, the wife of Bad Company drummer Simon Kirke and the mother of Jemima Kirke—the actress who plays the gypset character Jessa on HBO's *Girls*. Lorraine recently traded her mega family estate in East Hampton for a smaller, boho summer cottage in the Springs—the heavily wooded bay side of Long Island. Lorraine's beach house is a mishmash of brightly painted walls and so many layers of vintage fabrics that it could make a gypsy squint. Fishing nets are used in place of curtains, and in the yard an Airstream trailer is done up like a folk singer's caravan. "I wanted to create a little fantasy world for my family," says Lorraine. The reality is that, compared with the Hamptons, the houses in the Springs tend to be smaller and closer together; bayside beaches can be sharp with pebbles; and the woods are full of mosquitos. But the Springs is also full of artists, and the gypset vibe is strong.

The Springs' arty migration started back in the 1940s and 50s, when the Abstract Expressionists led by Jackson Pollock, his wife Lee Krasner, and Willem de Kooning decamped from New York City for the affordable, gray-shingled homes and makeshift barns-turned-studios. Pollock, who was sent to the Springs to dry out, bought a small house on Springs Fireplace Road overlooking the lazy salt marshes of Accabonac Creek, with money that he got from Peggy Guggenheim in exchange for artwork. He painted many of his drip masterpieces here, and Krasner produced her famed "Little Image" series. Pollock famously died in the Springs when he drunkenly crashed his Oldsmobile convertible into a tree in 1956. Today the Pollock-Krasner House and Studio operate as both shrine and museum.

Kirke's multi-textured porch is perfect for catnaps and day dreams.
Following pages: An Airstream trailer made over as a gypsy caravan.

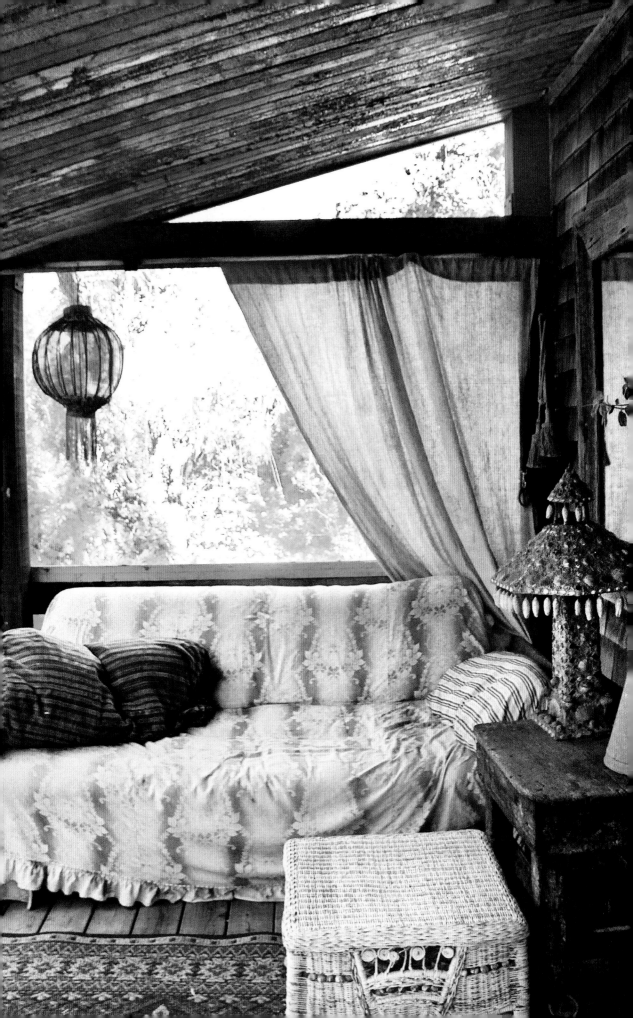

In the Springs, the artists coexist with a small, tight-knit, working-class community. The Springs General Store, (where Pollock used to trade art for groceries) is an old pine-shingled former post office built in the mid-1800s. There are wooden chairs on the front porch and Pancake Saturdays four times a month. Nearby, Ashawagh Hall, the de facto community center, throws the Springs' Annual Fisherman's Fair and exhibits local artists like Mary Bayes Ryan—The Barn's eighty-something-year-old matriarch. And then there's Fireplace Projects, a contemporary art gallery that opened a few years ago in a raw cinderblock automotive garage across from the Pollock-Krasner house. In the summer, the gallery openings spill out onto the gravel driveway and oil-stained parking lot. "I'm the farthest thing from an art snob," Fireplace Projects' owner Edsel Williams has said. Yet Williams only shows the A-list, including artists such as Laurie Anderson and Cindy Sherman—who just so happen to also have homes in the Springs.

Fireplace Road is the Springs' major thoroughfare, and at its farthest end lies The Barn. When Mary Bayes Ryan bought the compound in the early 1970s, it was a defunct summer camp called Fireplace Lodge. Mary was part of the 1950s California Big Sur art scene that included Henry Miller and hung out in places like Nepenthe and Schmidt's Tub. (Schimdt's Tub was reincarnated as the Esalen Institute in 1962—and then became famous as the place where the luminaries of the hippie movement took off their clothes, climbed into the hot tubs, and invented everything we now call the trippy sixties.)

At around noon on a recent summer's Saturday, I joined in on The Barn's spontaneous holistic triathlon. It started with an hour's worth of Ashtanga-style yoga, then a swim in the bay out to various rocks, and ended with our thumbs out, trying to hitch a ride to Montauk on a passing boat. The place—and the pace—is not too different from Mary's Big Sur days.

But now Mary's grown sons, known around town as the Ryan Brothers, run The Barn. And they are very of-the-moment. Oliver started the fitness website socialworkout.com and his brother Maxwell runs the interior design-based Apartmenttherapy.com. So, the social experiments taking place at The Barn today are not about rebirthing and astral healing and other Big Sur concerns. Rather, The Barn is a "laboratory for life," and a place for something they call "conceptual living." The idea is to spend an entire weekend developing and exploring, well, an idea—a concept. Ideas get green-lighted if enough passion and zeal are exhibited. Like when some engineer friends had the notion to create a natural hot tub, right on the beach. They dug a big hole in the sand, lined it with rocks, and gunned the battery in a pickup truck to pipe in seawater from the bay through a raging bonfire and into the pit. Miraculously, the concept worked. Amazing au naturel soaking sessions ensued all that summer.

Following pages: Leilani Bishop, a Hawaiian-born fragrance designer/model/surfer, strikes a pose at the Ryan family barn.

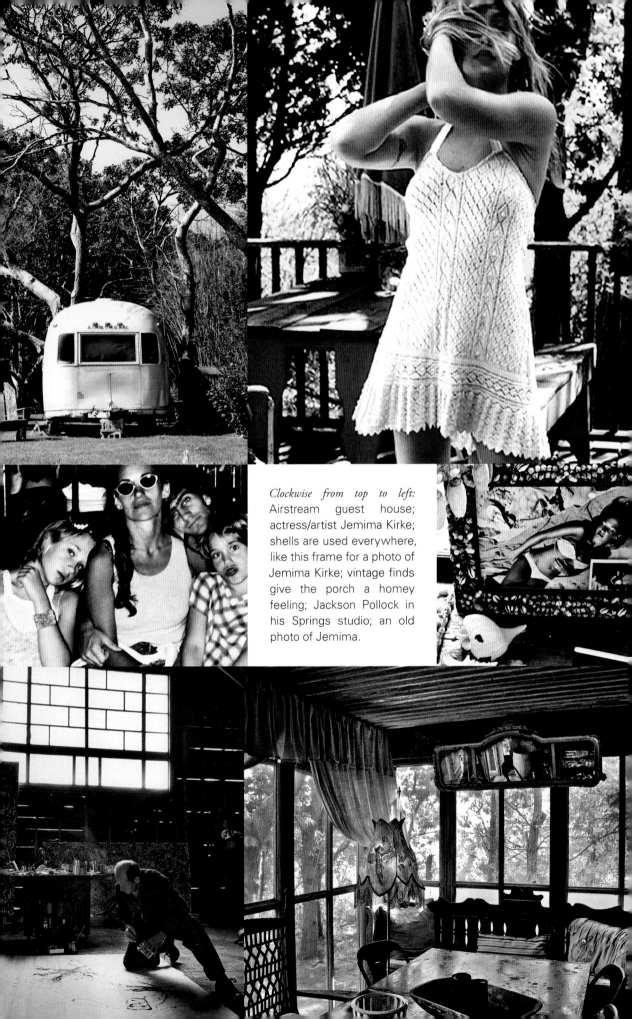

Clockwise from top to left: Airstream guest house; actress/artist Jemima Kirke; shells are used everywhere, like this frame for a photo of Jemima Kirke; vintage finds give the porch a homey feeling; Jackson Pollock in his Springs studio; an old photo of Jemima.

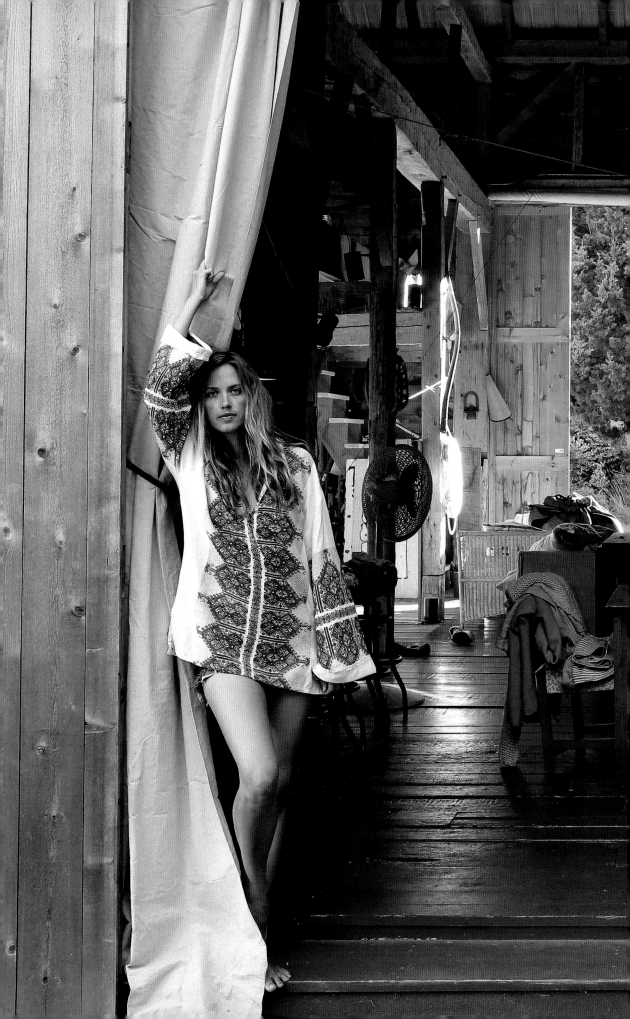

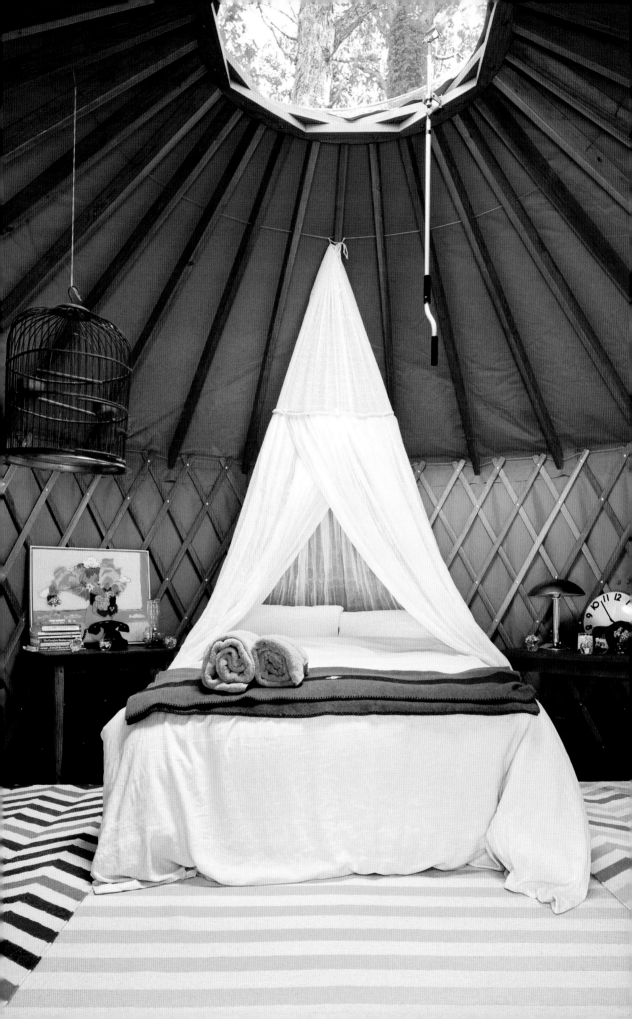

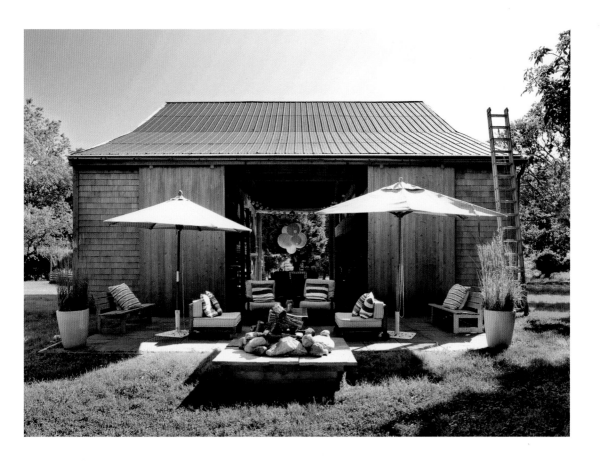

Social happenings are a major part of the Ryan Brothers's life laboratory. A small DIY army of friends is always racing around with construction materials and handmade signs under the direction of Oliver, who at The Barn has the look of a soulful, former preppy with a yoga-toned body, disheveled hair, and a leader's uniform of worn-out flannels and faded T-shirts. "The aspiration was that even the keg parties had to be conceptual," he says. The parties, he explains, can be anything from square dances and talent shows, to weekend-long costume soirees where everyone is required to stay in character. To ward off wayward crashers from the Hamptons, high heels have been banned periodically. "We didn't make the utopia," said Oliver of the transformative powers of growing up at The Barn. "The utopia made us."

The fashion world has taken note, perhaps because of the scarcity of such eccentric homesteads in these parts. Photographer Bruce Weber occasionally rents out The Barn for ad campaigns. Camilla Akrans thought the yurts were the perfect backdrop to shoot Rihanna's album cover for *Loud*.

But really, The Barn effortlessly ignores all that celebrity adulation (very gypset!) because deep down its ethos is more commune than socialista. Take lunch for example: on the day of the slacker triathlon, it started at four o'clock with guests freshly soggy from our ocean crawl. Oliver sends me into the organic garden with a pair of scissors to gather lettuce for the salad. When I get inside the

Above: The Barn in a rare moment of organization and repose.
Opposite: Cheerful geometry and color add a beachy vibe to the interior of this summer yurt on the grounds of the Ryan family barn.
Following page: Grab a chair and have a seat at the bar.

Above: Signage left over from various parties.

Above: A hot tub powered by two woodburning stoves.

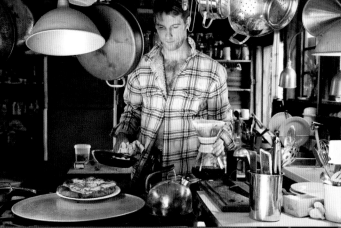

Above: Oliver Ryan prepares lunch.

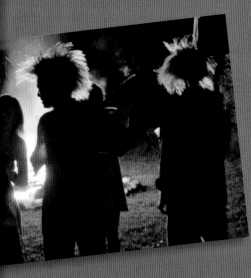

Above: Tribal revelers at a Barnonia bonfire.

Above: Analog atmosphere during late garden lunches.

gates, another guy is already there, deeply immersed in selecting the perfect red chili peppers for a batch of artisanal tequila cocktails. Oliver is whipping up pizzas in the kitchen that has so many stacks and shelves of pots, pans, measuring cups, strange utensils, and jars of spice that it resembles a hippie science project. A very civilized lunch is served around a picnic table in the garden with jazz playing on a portable record player plugged into an extension cord in the dirt. I feel less like a crasher now, and more like part of The Barn's extended family. Eventually, the sun begins to set and a friend of Oliver's, who's living in one of the yurts for the summer, hands out hula-hoops. Because really, how can you have a utopia without hula-hoops?

Above: Hula-hooping is a favorite pastime at The Barn.
Opposite: All you need: nature views, a bed, and nothing more.

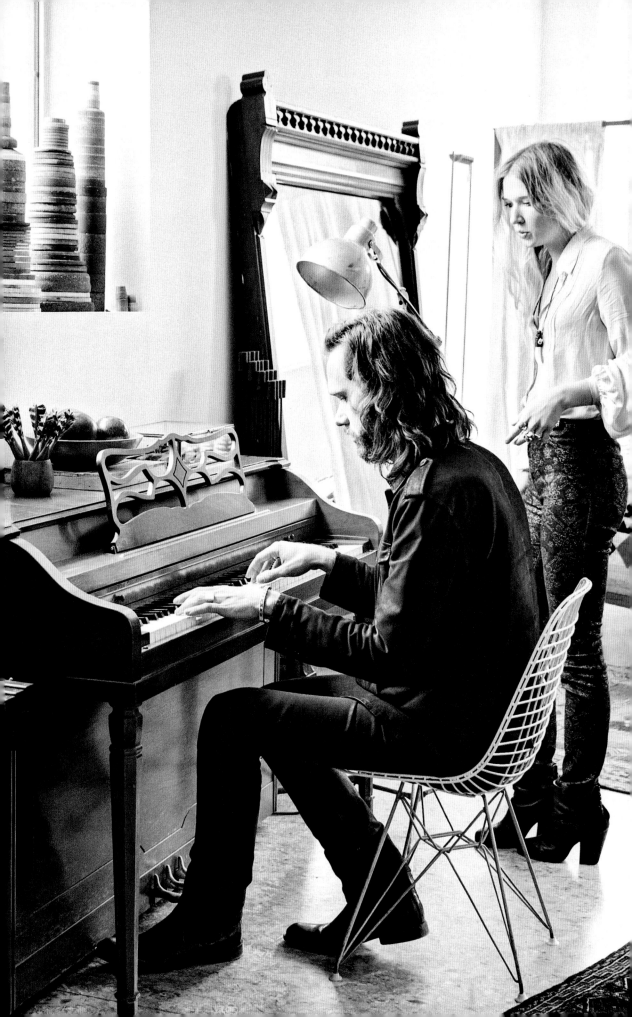

On-the-Road

WILD BELLE

*Gypset Rule #7: Climb a mountain, hold up your lighter,
and shout out the word "nomad"... really loud.*

So far, I've focused on gypset locations and entertaining. But Gypset is very much about the freedom to wander—just like the gypsies in their flamboyant caravans did so many hundreds of years ago (and still do, today). And what could be more nomadic—and gypset—than a rock band perpetually on the road. Not just any rock band mind you, but one that records tracks in the hills of Jamaica and hangs out in Brazil whenever possible. Ladies and gyptlemen, introducing Wild Belle, the polyglot duo featuring brother and sister Elliot and Natalie Bergman—Elliot, thirty-two, plays saxophone and keyboards, and Natalie, twenty-five, sings.

The band's debut studio album, *Isles,* was released in 2013, and since then the act has become the darling of the fashion world and the festival circuit—one and the same these days. A typical season will have Wild Belle performing their boho contrail of breezy reggae, 1970s Africana, and Motown soul at Coachella, Lollapalooza, and Carnaval de Bahidorá in Mexico City. "It girl" Alexa Chung handpicked the band to play fashion parties for brands Mulberry and Maje, and when Natalie and Elliot went to Jamaica recently, *Vogue* asked them to do a photo travel diary. In keeping with their hip aesthetic, they made a pilgrimage to Firefly, British expat/renaissance man Noël Coward's former estate near Oracabessa. But my favorite image is of a make-up free Natalie wearing a 1940s style Hawaiian print dress in a tropical garden overlooking Montego Bay strumming a vintage guitar. "Natalie playing a little Della Humphrey tune on her Stella," the caption reads.

Wild Belle's brother and sister duo Elliot and Natalie Bergman compose at Elliot's loft in Chicago.
Following pages: Natalie and Elliot are inspired by the landscapes they pass while driving between shows. Here is Natalie and Kyle Morrison filming a video in the desert in the American Southwest.

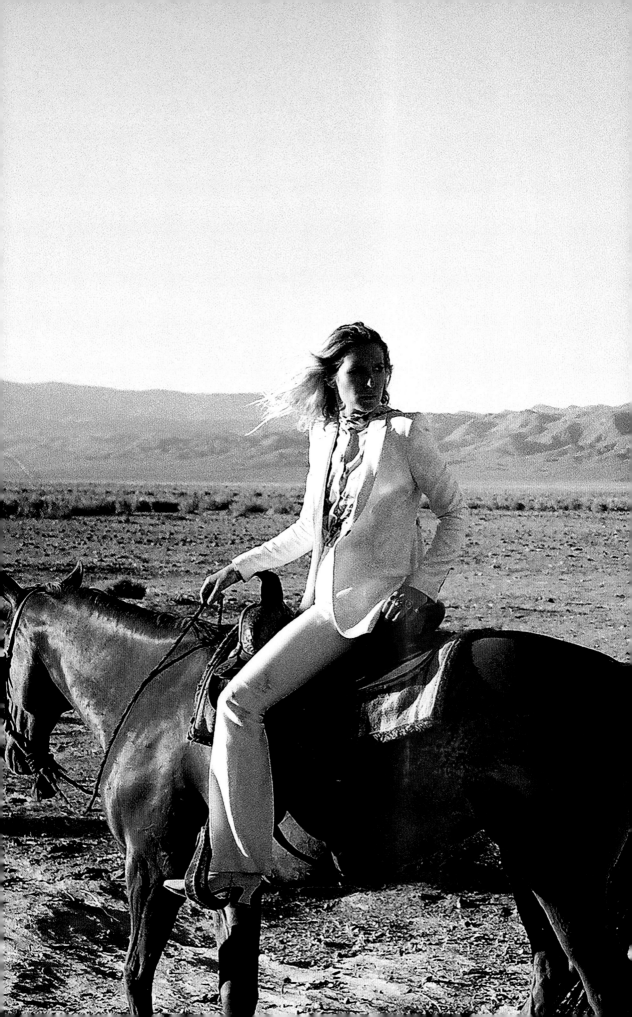

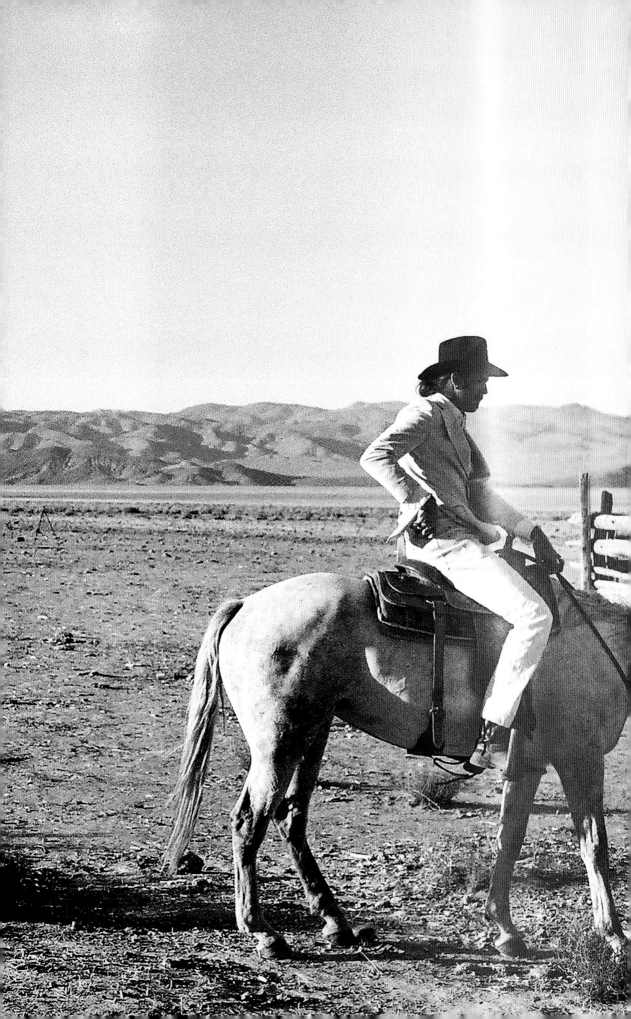

Elliot and Natalie grew up in Chicago with their musician/writer mom who was always playing jazz standards on the piano and whisking her family off on various trips to India and Kenya. "I'm sure that has something to do with our longing to wander around and be on tour," said Natalie who attended Berklee College of Music. Elliot studied jazz, African drumming, and Gamelan music at the University of Michigan while moonlighting at the famed Ann Arbor record store Encore, where he obsessed over the vast vinyl collection.

"In a way you start to travel with your ears," said Elliot. "You start to connect the dots through your record collection. Like the great dialogue between Africa and the United States that started in the 1960s: James Brown influencing Fela Kuti and Fela influencing the Talking Heads. You start to see the way music finds its way back and forth across cultures and oceans. And it's also a great place to find inspiration with colors, and pattern, and fashion." So when they needed to make a video for their song "Backslider" quickly and on the cheap, they enlisted their younger brother Bennet, twenty-one, as director, and rummaged through their mom's old boxes and found slides of African artwork and tribal masks, and photos from her trip to Hong Kong and Australia in the late 70s and early 80s. They projected the slides onto Natalie's body as she danced in front of a wall, giving it a cool 1960s lo-fi feel.

As all great gypset things do, Wild Belle started pretty much by accident. Elliot was living in Williamsburg, Brooklyn, working at the nightclub Zebulon and building and recording electric kalimbas as part of his Afrobeat jazz band Nomo. Natalie had been going on tour with Nomo since she was sixteen, selling merchandise and hanging out. But one day, she got ahold of one of Elliot's instrumental tracks and decided to add her vocals, staying up all night writing and recording it in the GarageBand app. The rest is history.

What makes Wild Belle so gypset is a sonic and visual identity that draws from elements that span continents and decades. A single song might reference Studio One reggae, Kate Moss, Nancy Sinatra, and *Space Is the Place*—the 1970s science fiction film starring Sun Ra. It's a far-flung jet-lagged mix that somehow works. Listening to Wild Belle feels like going on a tropical, galactic getaway with lots of legroom and no flight delays. "We're not a world-music band," Elliot explains. "But we are influenced by things around the world." Unlike Led Zeppelin who toured in the 1970s aboard their "Starship," a Boeing 720 with an organ built into the bar and the band's logo emblazoned on the side, Wild Belle flies commercial—or drives. Their modest caravan consists of two Ford Econoline vans. One is for equipment, and the other for the band members, has just the essentials: a dream catcher, a Jamaican flag, and in the back, Natalie's stage wardrobe. It's a vintage trove that she acquired on the road, like a black top hat she scored in Madrid and a turquoise Navajo necklace from Albuquerque. "We'll go out of our way on tour

Elliot collects Africana and old vinyl.
Following pages (left): Elliot color blocking in Jamaica.
Right: Natalie plays a Della Humphrey tune on her vintage Stella in Montego Bay, Jamaica.

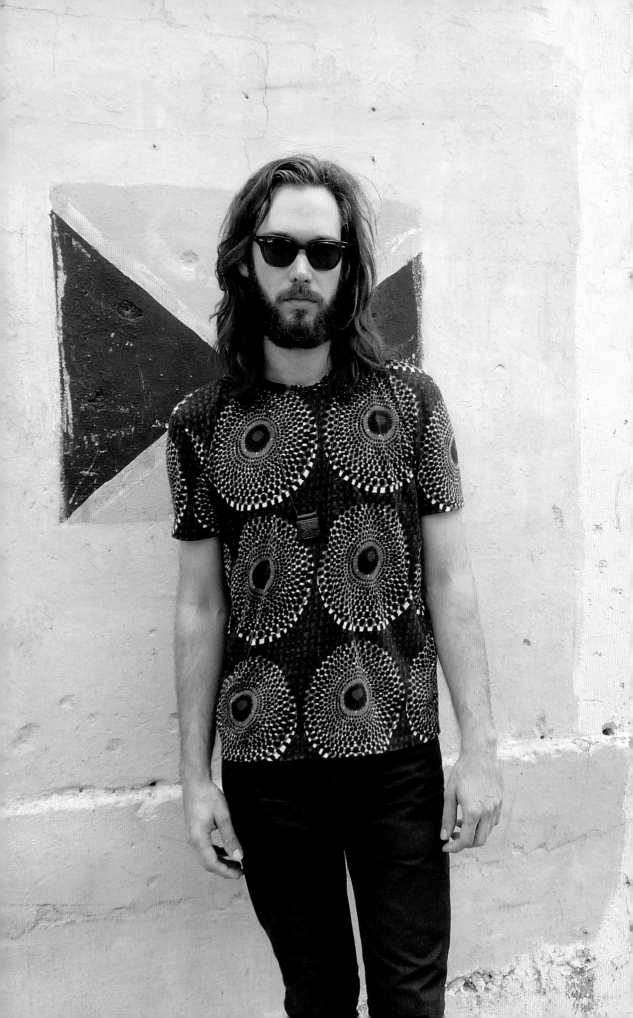

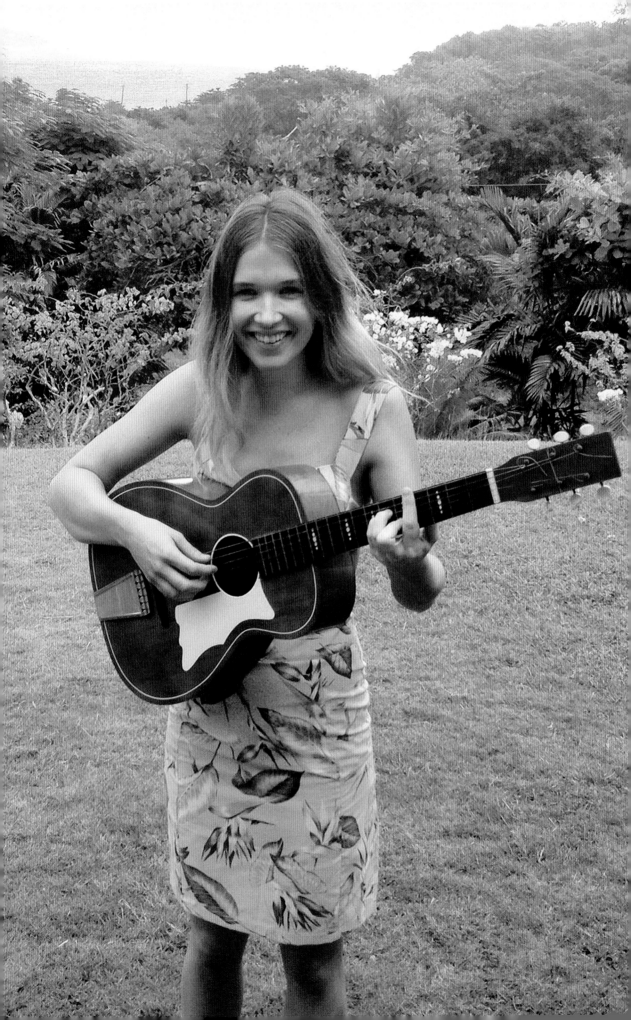

to wake up early and forage," says Natalie. Sometimes when they are motoring between gigs they are so awed by the landscape, that they pull over on the side of the road, hop a fence, and do impromptu photo shoots and videos. During a trek from San Francisco to Chicago, en route to Lollapalooza with their director brother Bennet, they stopped at the defunct salt-mine town of Mina, Nevada and the Bonneville Salt Flats in Utah and filmed the video for "Another Girl." In it, Natalie is riding around on a chestnut horse in a 1970s Bianca Jagger-style white tuxedo. The look was inspired by the Chilean-French director Alejandro Jodorowsky, and the tux was tailored by her other sister Elise, twenty-nine, a fashion designer. "Its amazing that you can just shoot and no one stops you," says Natalie. "It's really freeing."

Being modern nomads also has its challenges, of course. Particularly when it comes to lodging. "Our Airbnb credibility is pretty bad," admits Elliot. "Hardly anyone will rent to us anymore." "We usually have guests over after our shows," Natalie explains. "And we can get pretty loud." Luckily, it was their manager's profile that got ruined, not theirs. Often, the Wild Belles will just crash with friends. They've also been known to make detours for the sake of style, driving hours out of the way to stay at such classic Americana haunts as the Hotel Colorado in Glenwood Springs, Colorado, or The Hotel Congress in Tucson, Arizona. Sometimes, the stars align and they get fortuitous invitations from fans—like in Glasgow, for example, when they bunked at a private castle, or in Aspen at a ski chalet with a Jacuzzi in the yard.

Increasingly, the exotic world presented on their extensive record collections is merging with real life. Like on a recent tour in Brazil: Both Natalie and Elliot are huge fans of Tropicalia, the 1960s Brazilian artistic and activist movement that included such musicians as Caetano Veloso, Gilberto Gil, and Jorge Ben. "The first night we were in São Paolo, we hung out with this singer Ana Canas and she played these beautiful songs in her courtyard, and then she was like, 'now let's all play. Grab a tambourine and you take the drums.' And I thought it's really true, this does happen in Brazil," said Elliot.

While in Brazil, Elliot and Natalie acquired even more old vinyl and vernacular instruments, which is one of the reasons Elliot recently rented a loft in Pilsen, an industrial area of Chicago. Part crash pad, part museum, part storage locker, and part recording studio, the place is stocked with anthropologic displays of goat bells from the Maasai Mara in Kenya, bongos from Ghana and Amazonian maracas adorned with bird feathers—and of course, Elliot's impressive closet of thrift shop blazers and dress shirts. Elliot plans to keep the loft—at least until they are done recording their next album. And then it's back to spinning the globe. "We've never been to Japan," muses Natalie. "Or maybe Bali," says Elliot. "Weren't you just there? How was it?"

Above: Elliot collects vintage blazers and dress shirts to wear on stage.

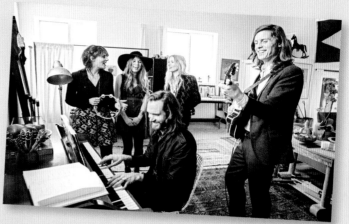

Above: A jam session with friends in Elliot's Chicago loft.

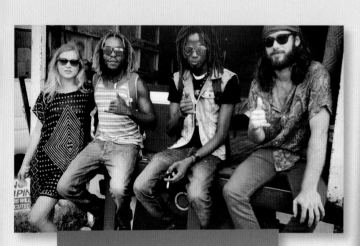

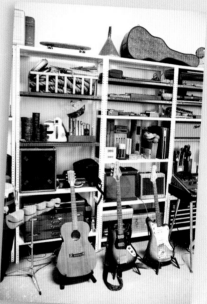

Above: Wild Belle's recording studio and vintage instrument collection.

Above: Natalie hangs out with new friends while recording in Jamaica.
Below: On tour in the Econoline.

Above: Elliot uses grindstones he finds at flea markets to make electric kalimbas.

Communal Compound

TOPANGA CANYON, USA

Gypset Rule #8: Always be open to spontaneity.
Even when it comes to communes and weird yoga poses.

I'm in lotus position with my arms outstretched. The instructor, a woman in a purple headscarf and turquoise necklaces, is sitting on an outdoor dais. "Only eight more minutes to go," she commands in an authoritative South African accent. Normally, endurance and discomfort, even for some type of delayed enlightenment, is not my thing. But I'm here to assimilate, I remind myself. How bad can it be? "Five minutes."

Three minutes of my life have never ticked by more slowly. I'm desperately trying to keep my arms up. They're shaking like rubber bands. In an attempt to distract myself, I look around and take an inventory of my surroundings. A dog lazes in the shade. Potted plants and flowers refract the sun. A parachute shades the teak yoga platform overlooking the arid, sun-splashed terrain. Even still, sweat trickles down my face. "Two minutes."

The weekly Kundalini yoga class is being held at a luxe bohemian compound in Topanga Canyon belonging to the model and eco-activist Angela Lindvall. The other yogis, clearly regulars with sheepskins padding their mats, include a commune dweller and a tantric sex therapist. They all have on some combination of a white turban and loose Indian print harem pants. It feels refreshingly culty and exotic—a sure sign that I'm on the right track. But my arms are about to fall off. "One minute to go."

The mission. I must remember the mission. I have come here seeking the beating heart chakra of the nouveau new age. It is definitely alive and revving here in Topanga Canyon, a fervently

Topanga Canyon land art.
Following pages: Communal art: The Great Wall of Topanga.

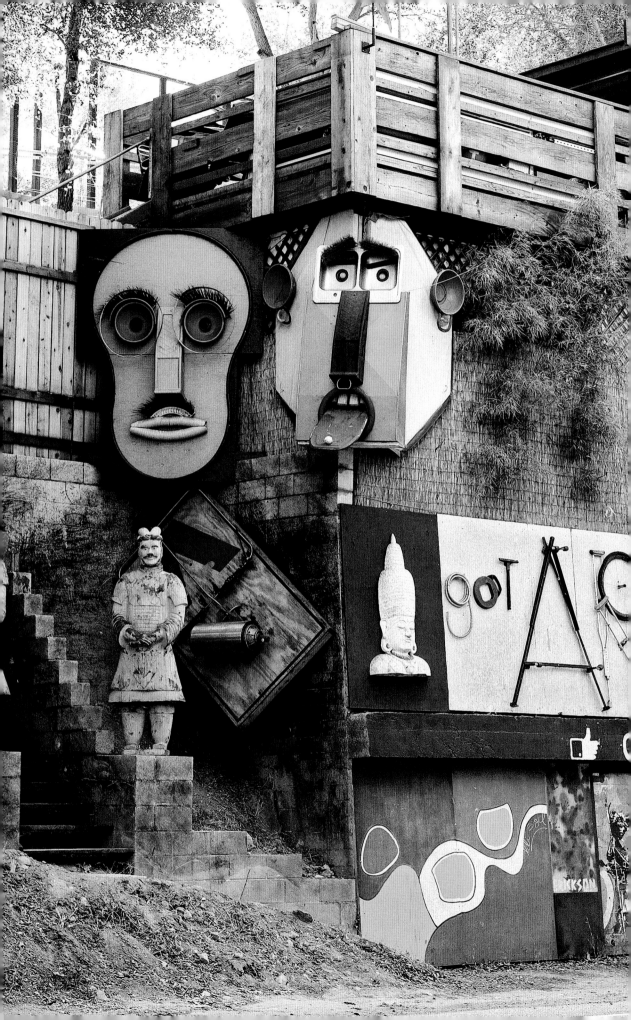

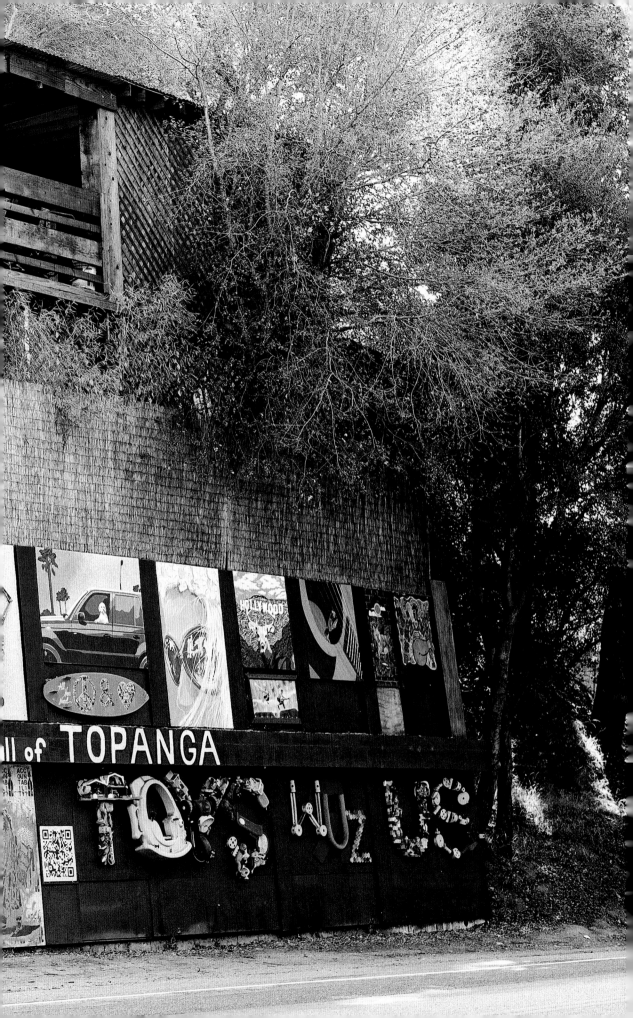

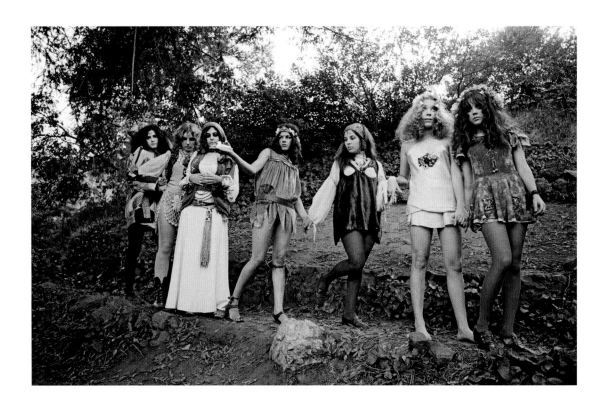

preserved gypset enclave tucked between the Santa Monica Mountains and the Pacific Ocean. I call the current dawning of Aquarius the "nouveau" new age because, unlike the 70s and 80s, this time around the movement is more chic—it's as much about philosophy as aesthetics. And in Topanga, the two are interchangeable.

Topanga became an alt capital at least as far back as the 1940s when "Nature Boys" migrated to the canyon to live in caves, grow their hair, eat raw food, and practice nudism. Jack Kerouac noted these pre-beatniks in *On the Road* while passing through Los Angeles in the summer of 1947, where he saw "an occasional Nature Boy saint in beard and sandals." Hobo-activist Woody Guthrie and beatniks such Wallace Berman arrived next, the latter publishing the utopic literary journal *Semina,* which prescribed "a new life way." It was a pastiche of philosophy and art, everything from surrealism to Kabbalah. The hippies showed up in the 60s to try to put those ideas to work in their crash pads and communes. One of the longest-lived, Summerhill Ranch, was inhabited by artists, surfers, and screenwriters up until a few years ago. One of the most famous Topanga communes was The Sandstone Foundation for Community Systems Research, which Gay Talese documented in *Thy Neighbor's Wife,* his first-person inquiry into the sexual revolution. A two-story home on a Topanga mountaintop with a big fireplace and gold shag carpets, Sandstone was a free love commune.

"It was like the Algonquin," former Sandstone resident Marty Zitter has said. The upper floor was home to an eclectic community of sexual and political radicals. "People would go downstairs

Above: Pop group and goupies, The GTOs (Girls Together Outrageously) in Topanga, February 16, 1970.
Opposite: The bedroom of gypsetter Uschi Obermaier, the German activist, model, and jewelry designer. The Indian sarongs on the ceiling came from a road trip Uschi did from Germany to India aboard her tricked-out Mercedes bus in the 1970s.

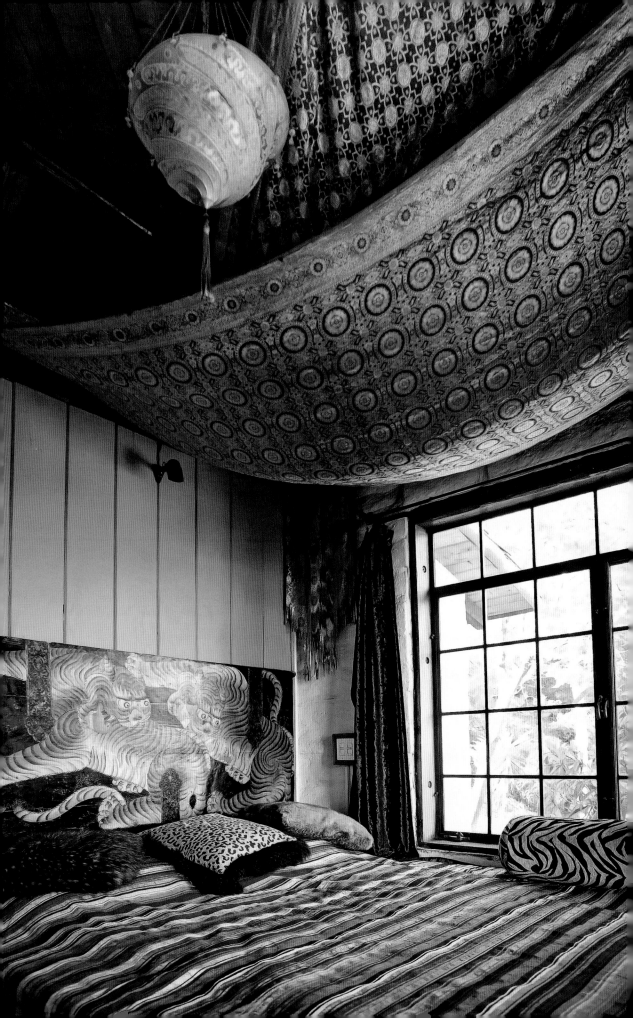

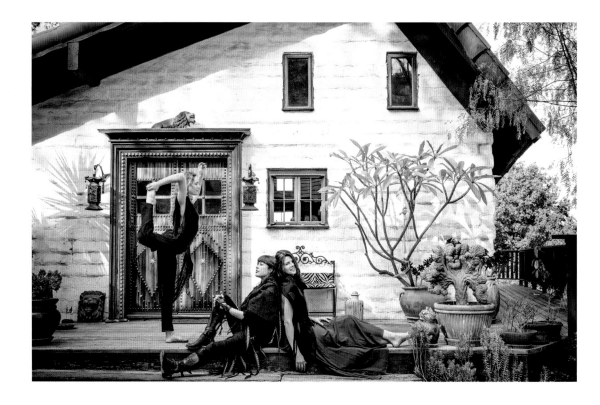

and have sex," Zitter explained, "and then they'd come back up and talk some more. Some people wanted to have sex right there in the conversation."

Topanga's experimental lifestyle inspired its own distinct sun-kissed sound. Neil Young's *After the Gold Rush* was recorded partly in his basement here. Other local musicians included Jim Morrison, Emmylou Harris, and Gram Parsons, who would often jam into the wee hours at the local nightclub, The Topanga Corral.

Surrounded by some of LA's glitziest and most materialistic neighborhoods—Malibu to the west, the San Fernando Valley to the north, and Hollywood to the east—Topanga nevertheless remains bohemian. Drive up to tiny downtown Topanga from California's coastal Highway 1 and you will invariably see a hitchhiker with a guitar and an outstretched thumb in front of the "Great Wall," a polyglot art installation featuring Buddhas, Hindu deities, Polynesian totems, and junkyard sculptures.

In town, the boutiques stock Native American mukluk boots, feather earrings, and bespoke dream catchers. An old 1960s camper or adobe yurt tops every hill. On Friday night at the local hangout, Froggy's, I easily befriend a surfer-turned-writer hiding out from the Manhattan winter, and a few members of the band Promise of the Real. The band invited me to visit them down the road at Wildwood, a funky old summer camp from the 1920s where they were living and working. The living room is stuffed with recording equipment and surfboards. "You can feel a sense of

Above (from left): Artist Toree Arntz (in yoga stance), Uschi Obermaier, and fashion designer Taiana Giefer pose on the porch of Uschi's Topanga home. *Opposite:* Interior of what Uschi Obermaier calls her Spanish Chalet becasue of its mix of Iberian and Swiss architecture.

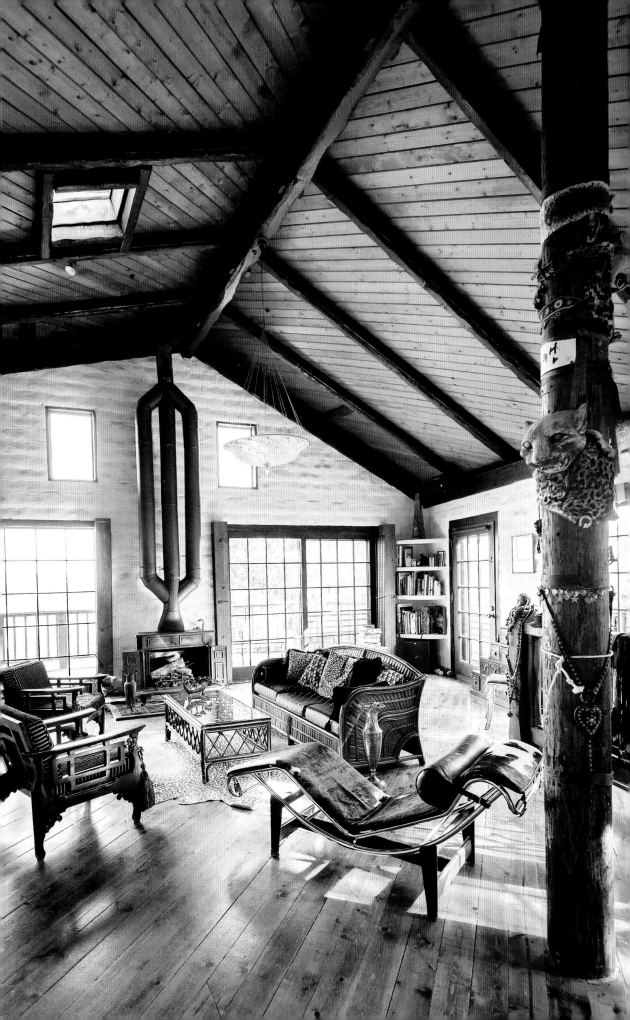

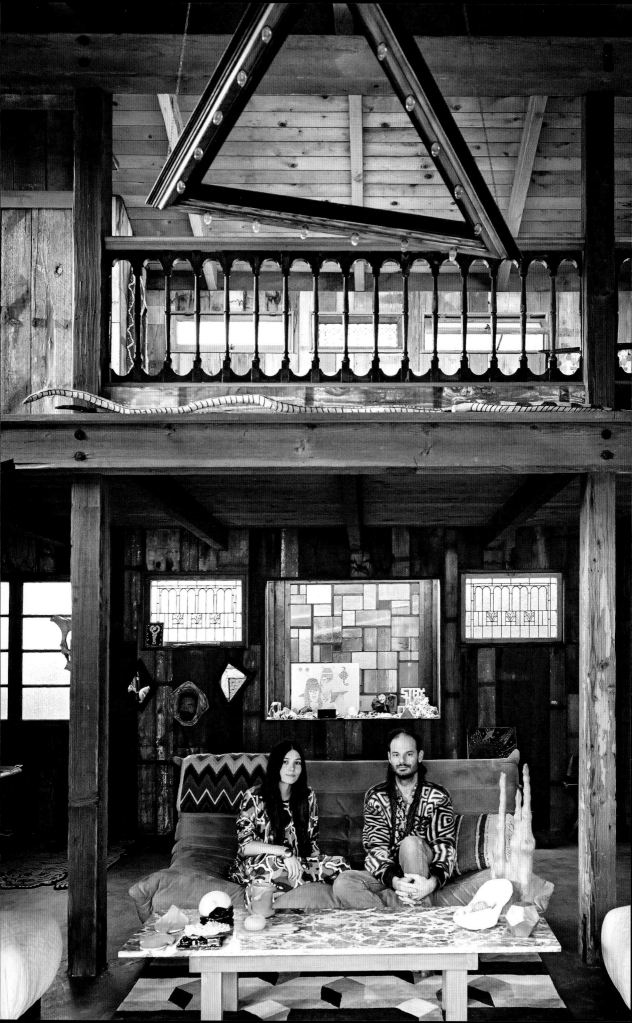

connectedness here," frontman Lukas Nelson says, putting a Neil Young album on an old record player. Lukas, twenty-four, is communing with the Topanga vibe while making his band's album. "Certain places are like energy vortexes, and Topanga is one." (Incidentally, another energy vortex is Pa'ia Maui, featured in Chapter 9, where the Lukas's band is also based and where his dad, Willie Nelson, has lived since the 1970s.)

But back to the nouveau new age: Topanga is not just about how groovy it was way back when. Lukas and his friends are part of a new bohemian generation: graphic designers, artists, and musicians whose work references the golden hippie era but which is infused with something new and fresh. Many of them grew up with boho parents and are trying to make sense of their childhoods through their art. But unlike for their parents, there is no glamour in dropping out. Almost everyone I meet in Topanga is highly functional. They've got websites and on-line stores. Some even have publicists. Life in Topanga is not a radical political statement anymore, but it's definitely a social one. Carly Jo and her husband Matthew Morgan, a young couple I meet, are perfect examples of the new bohemian type. They tried living in upstate New York, Brooklyn's Williamsburg, and Joshua Tree before settling in Topanga two years ago. Carly and Mathew have a band together and both are successful artists in their own right. They wanted a place where they could create but not totally check out. "There's a great community here," said Carly, whose brand All For The Mountain spans jewelry design to curating art exhibits. "It's a stimulating mix of people: New Yorkers, ex-models, crazy gypsy types, and a lot of yogis. We don't really ever leave."

Carly and Matthew renovated a compound that they bought from an eccentric beatnik ceramist. Next door is Neil Young's old recording studio, a sort of Topanga shrine. They set up their own art and recording studios on the property and rented out the remaining space to friends. The main house, an old wooden cabin with stained glass windows, is lofty and raw. A Tom Dixon disco chandelier hangs from the ceiling. The look is "space age meets Machu Picchu," according to Matthew. "A mix of handmade and machine made." His geometric sculptures and mirrors line the wall mixed with an esoteric book collection. "I'd hate to be called a hippie," said Matthew. "We try to not try too hard to do the same old thing."

Matthew and Carly often hang out at their friend Angela Lindvall's eco-wonderland nearby on a hillside complete with the aforementioned yoga studio, a chicken coop, an herb garden, and a charging station for hybrid cars. A true gypsetter, Angela used to live on a houseboat in New York City, but these days she can be found—between modeling gigs and traveling for various environmental causes to Uganda and Bali—in dirt-smudged gardening clothes. Her house is a modernist ranch-style done up in a gypset hybrid of Southwestern and Native American motifs, and

Carly Jo and Matthew Morgan in their woodsy Topanga lair. *Following page:* Carly Jo and Matthew have a band together, and a collection of vintage guitars and banjos.

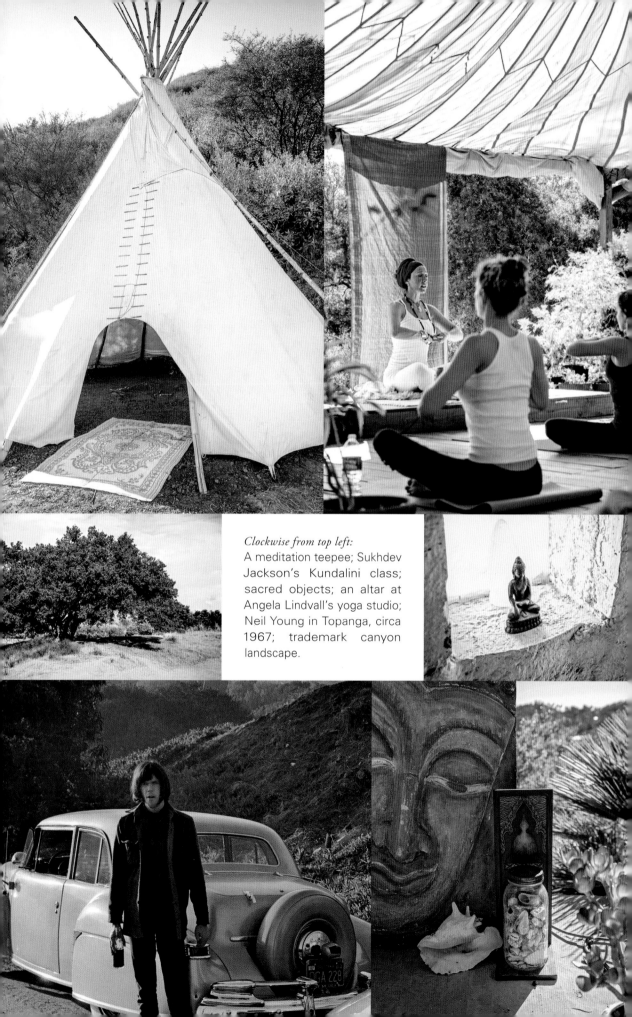

Clockwise from top left:
A meditation teepee; Sukhdev Jackson's Kundalini class; sacred objects; an altar at Angela Lindvall's yoga studio; Neil Young in Topanga, circa 1967; trademark canyon landscape.

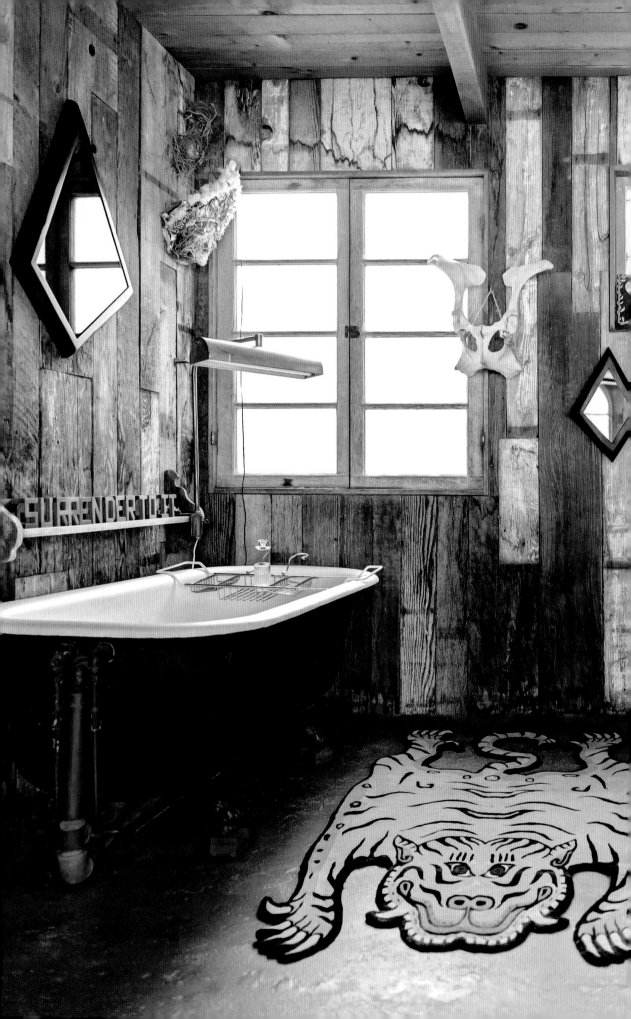

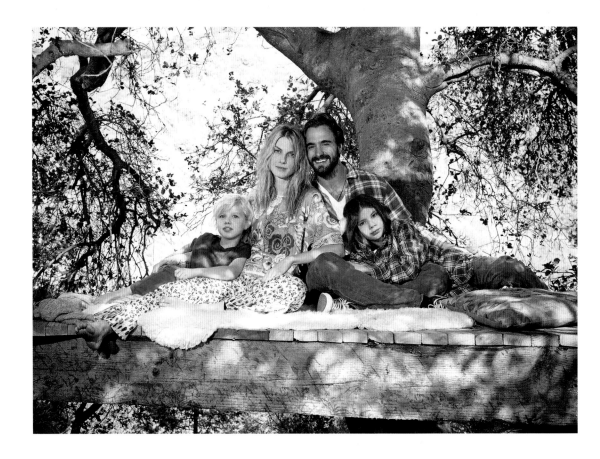

a Moroccan roof terrace with colorful poufs where she likes to hang out with her two sons, William Dakota, 12, and Sebastian, 9. In keeping with the Topanga, communal vibe, Angela is a generous host with a solar-powered yurt and several wooden cottages designated for houseguests. Instead of a fortress-like gate, the entrance to her driveway is marked with a friendly cardboard sign with swirly letters that reads "Yoga Class."

Another group that seems open to communal ways are the crew at the Tribal Oasis. At the end of the glamorous Kundalini yoga class at Angela's house, I strike up a conversation with Saskia, a woman from the Netherlands who tells me about the Tribal Oasis "intentional community" (as communes call themselves nowadays). Saskia, I soon learn, is the "spirit wife" of the commune's leader, DLight. The twelve-acre property by a creek is a de facto repository for Burning Man art installations, where the giant sculptures usually seen in the Black Rock Desert spend the other fifty weeks of the year. They lie about, dormant in the brush, some propped up against trees, all still coated with alkaline dust from the desert playa. The best of the bunch is a geodesic dome with attached xylophones and drums. It's a communal instrument and "sacred meditation dome" which travels to the Coachella Music Festival every year. Scattered among the art and the trees are makeshift shelters fashioned out of everything and anything: travel trailer shells, corrugated

Above: Model and eco-activist Angela Lindvall hangs out in her Topanga treehouse with her boyfriend and sons Sebastian (left) and William Dakota (right). *Previous pages (left):* Carly Jo and Matthew's style is an eclectic mix of contemporary, vintage, gifts from friends, and objects they make themselves. *Right:* The bathroom combines the found with Matthew's "sacred geometry" mirrors.

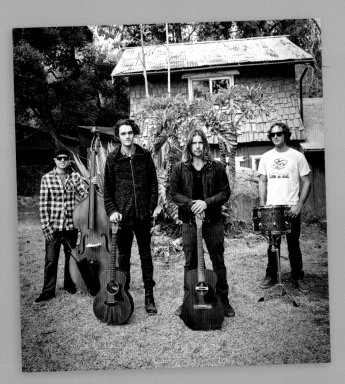

Above: Gypsetter Shiva Rose and her daughter Charlotte.

Above: Lukas Nelson (front right) with his band, Promise of the Real, recording at the Wildwood camp.

Above: Angela Lindvall's yoga studio shaded by a vintage parachute and Indian fabrics. Right: Carly Jo and Matthew Morgan's little puppy.

Above: Linda Ronstadt poses for a potrait in Topanga, 1968.

aluminum, even a wooden floor leftover from Jennifer Aniston's house. "It was brought here by a guy someone started dating at Burning Man," Saskia explains, which is the way a lot of things get built around here. The property has been a refuge to transients and dreamers, most handy with a hammer, since the Nature Boy era back in the 40s. People move in for a few nights, or a few years. Recently, however, Saskia and DLight evicted everyone, except a skeletal group that includes a beekeeper and a healer, in an attempt to turn the "chaos" into a bed and breakfast. Tribal Oasis is currently listed on Airbnb.com. (Note: You might want to bring your own sleeping bag.) Yet it's cool and very gypset: totally creative and freewheeling and weird, just as a personal utopia should be. I'm glad Tribal Oasis exists, and I'd love to rave here all night, but I'm pretty sure if I did, I'd go out for breakfast the next morning.

Above: A hippie shack at the commune/bed-and-breakfast Tribal Oasis.
Opposite: Angela Lindvall's planted roof terrace.

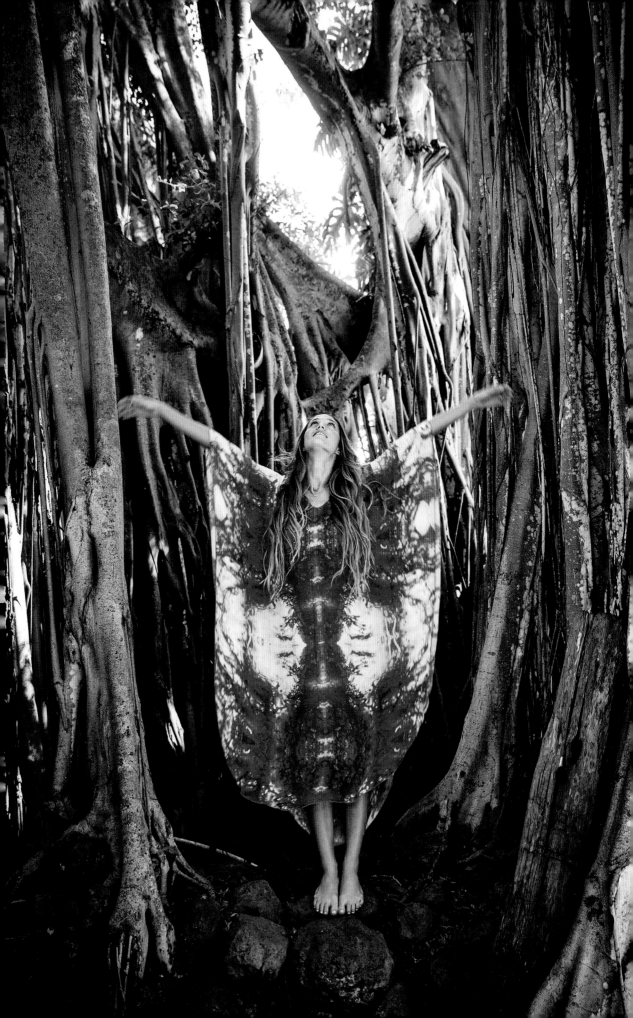

Off-the-Grid Utopia

MAUI, USA

Gypset Rule #9: If a mysterious stranger with a gleam in her eye offers you a dose of some special something, take it.

I arrive late at night at Halemano, a sort of hippie Four Seasons in Kipahulu, a remote off-the-grid farming community on Maui's southeastern shore. There's no reception desk, just a bulletin board with a treasure map to my room and a flashlight. It's all very *Lord of the Rings*. I explore the overgrown pathways past a few yurts and some modernist cabins. Little lizards scoot about, and I end up on soft green lawn shaded by stately palms on a cliff overlooking the Pacific Ocean. It reminds me of a scene that Slim Aarons would have photographed, if Slim Aarons had a four-wheel drive truck and smoked pot—which is what a few of Halemano's guests are doing while stargazing on a blanket and listening to bossa nova on their iPhone. I encounter them on the search for my room, which turns out to be a freestanding Balinese hut perched, off by itself, on a jungly hillside. It's the size of a closet but incredibly chic: just a big bed with nothing around it but decadent nature. Bathrooms are shared, with the showers only semi-concealed. In place of room service, there's a communal kitchen. I feel like a houseguest free to frolic on the choice estate of some distant benefactor. Wandering through a garden gate, I find the gravesite of Charles Lindberg, the famous aviator, activist, and writer who lived in Kipahulu in the 1970s. It's sort of like Jim Morrison's grave in Paris, but Lindberg's tombstone is decorated with plastic airplanes and leis. After paying my respects, I make my way back to my hut and my head finds its pillow.

The next morning I wake to discover that though I've meant to come to Middle-earth, I've actually arrived in the middle of town. Kipahulu, in the foothills of the mighty volcano

Surfer Monyca Byrne-Wickey in Kipahulu.

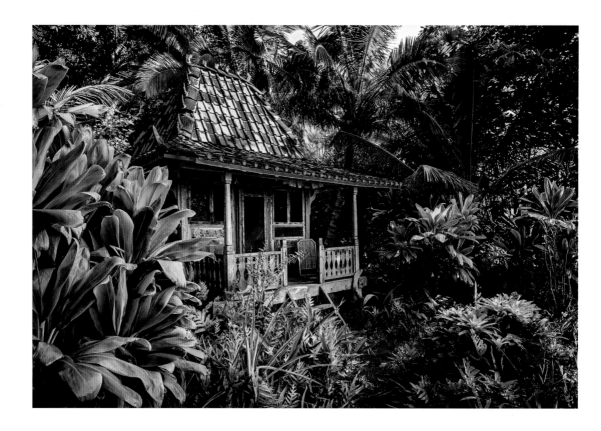

Mt. Haleakalā, is a settlement so small that the only restaurant is actually in a van, parked on the side of the pocky, dirt road. It's not just a good place to get organically-grown Thai Food—it's the center of Kipahulu's social scene. Everyone in town comes by to eat and trade info on ride share apps, GMOs (Genetically Modified Foods) and permaculture techniques. "If the boat stops coming," they like to say, "we're prepared."

In Kipahulu, self-sufficiency is a form of activism. In other words, the fewer trips to Costco in Kahului, on the other side of the island by the airport, the better. Even the entertainment is mostly homegrown. One of the young WWOOFERs that I meet invites me to a guitar sing-a-long later that night at the home of a Dutch man named Martin. (WWOOFER stands for World Wide Opportunities on Organic Farms, an organization that connects volunteers with host farms from New Zealand to Tuscany to Hawaii.) There, I meet Jeanne, a cheerful, older woman with curly blond hair tucked under a bandana, who runs Café Attitude, Kipahulu's weekly hootenanny. She tells me to stop by her powwow tomorrow.

It's easy to find Jeanne's place. The first thing I see is a purple painted shipping container with a flying saucer sign on it saying "Cargo Ship." The WWOOFER types here seem like they've stayed longer than a few months: they've shed their collegiate skins and gone totally native. A young man with a sheet of long blond hair covering a bare chest hacks up coconuts with a machete, and a

Above: Guest quarters at Halemano Resort in Kipahulu.
Opposite: Balinese carved doors, wicker chairs, and tropical vegetation make an idyllic hangout nook at Halemano.

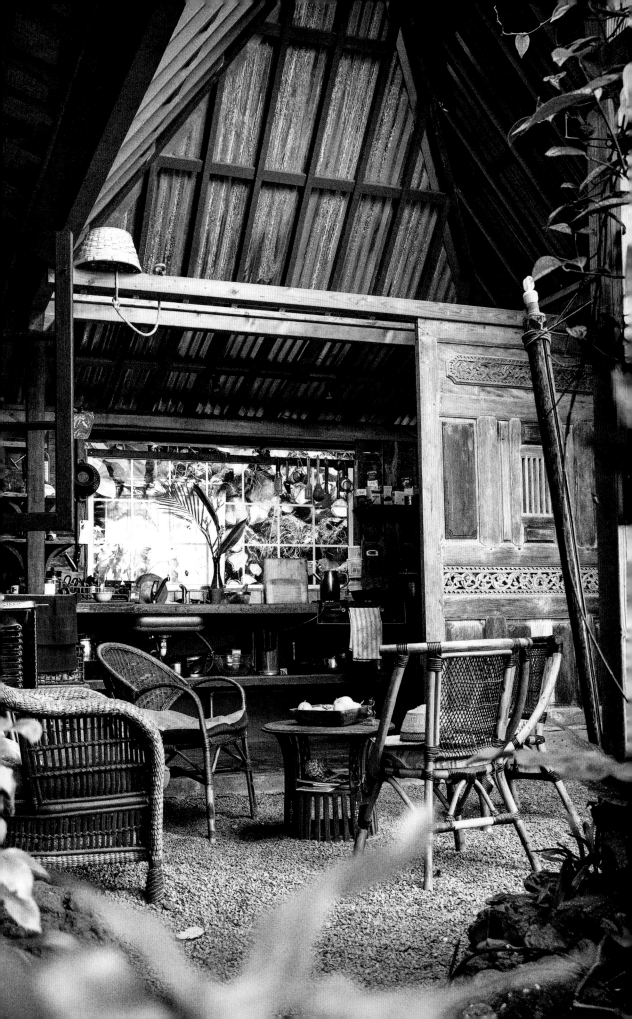

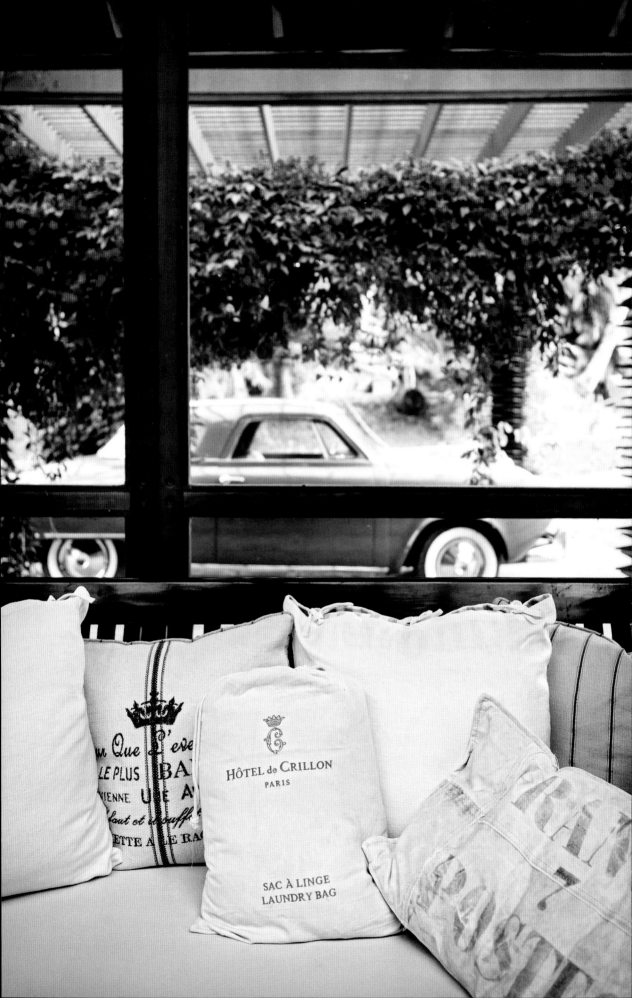

naked guy who I recognize as the guitarist from last night is in lotus position on the bank of a duck pond that's being used as a dipping pool for the homemade sauna. Several bamboo huts are tucked into trees and someone asks if I'd like to rent one. I find Jeanne gardening with a couple of young WWOOFER girls in tight denim cut-offs—the only kind really.

"Here, try some of these." Jeanne unties a medicine pouch and pulls out several reddish flowers called spilanthes. "They'll make your mouth feel like its tripping fireworks." I obediently chew one up, and yes, it's just like Jeanne said. "Oh, I forgot to tell you to chew them carefully," Jeanne adds. "If they activate in your throat you wont be able to breathe."

I get her point. Kipahulu's seductive nature is as beautiful as it is risky. Be seduced, but also take responsibility for yourself. I follow Jeanne inside the main house, Charles Lindberg's former writing cottage, apparently—and it's all floor cushions and tapestries used for meditations and ceremonies. She tells me she's a priest and that positivity is the religion.

"Do you want a homemade popsicle?" she grabs several from the fridge. "Um, is there anything in them?" I ask. "Don't you think I would tell you if there was?" she smiles.

I can't really tell if this is some sort of trust exercise, but the frozen treat is beginning to melt so I lick it. I like Jeanne, even though she seems a little dangerous. (Come to think of it, I like her *because* she seems a little dangerous.) She uses words like "abundance," "appreciate," and "universe" a lot but it's done in her Long Island, New York accent with an edgy humor that makes the idealism amusing. People are in a good mood around here. If I were going to WWOOF somewhere, I'd definitely choose Jeanne's place.

Jeanne's backstory is convoluted and strange—probably because of the fact that by the time she tells it to me, I had too much to drink and smoke. But basically she started the clothing company Flax with her now ex-husband Matthew Engelhart in the 1980s. They had some type of a spiritual "conversion," sold the company for several million, and divorced. Matthew joined the Landmark Forum and he started the feel-good California-based restaurant chain Café Gratitude. Jeanne came to Kipahulu to build a sustainable dream homestead. But she needed help tending the land. And then she needed more help. And soon so many people showed up that it grew into a sort of a commune. I guess that's how these things get started.

The Café Attitude party later that night is beyond exotic. My new best friends include an older hippie with a long white beard and a ponytail, and a young Tarzan guy who moved to Maui to smoke pot and collect coconuts. We feast on heaping plates of homegrown food with descriptions like "radical renegade ratatouille" and "Shiva luscious greens." A stage and a microphone have been set up and Jeanne starts off the festivities with her "Thank You" song. "Thank you, thank you, thank you.

Artist Tom Sewell's inspired living area in the hills above Pa'ia.
Following pages: Two musicians sprucing up al fresco at a bungalow on Jeanne Angelheart's compound in Kipahulu.

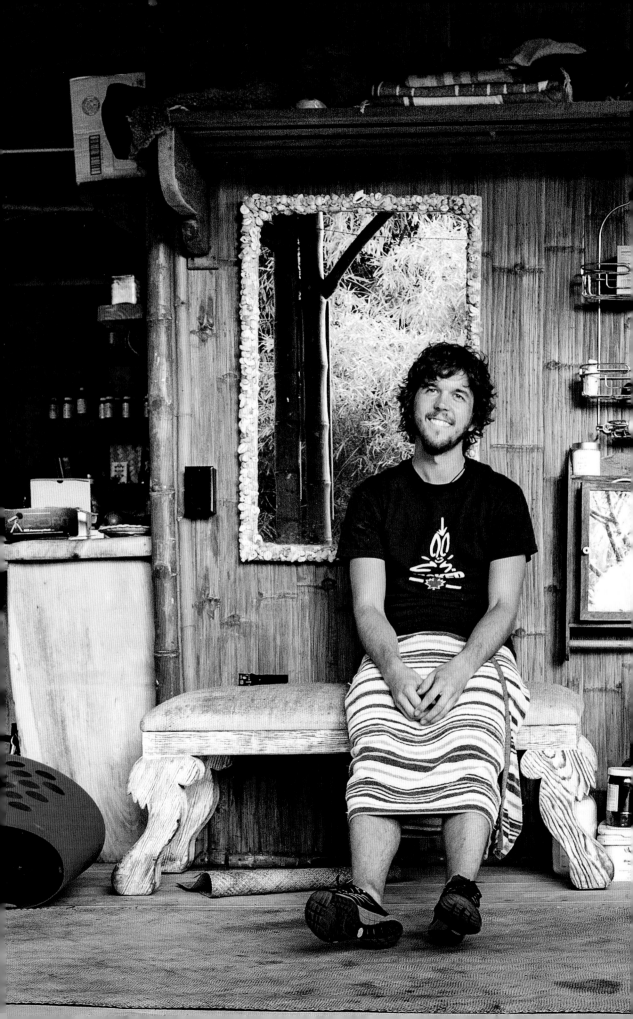

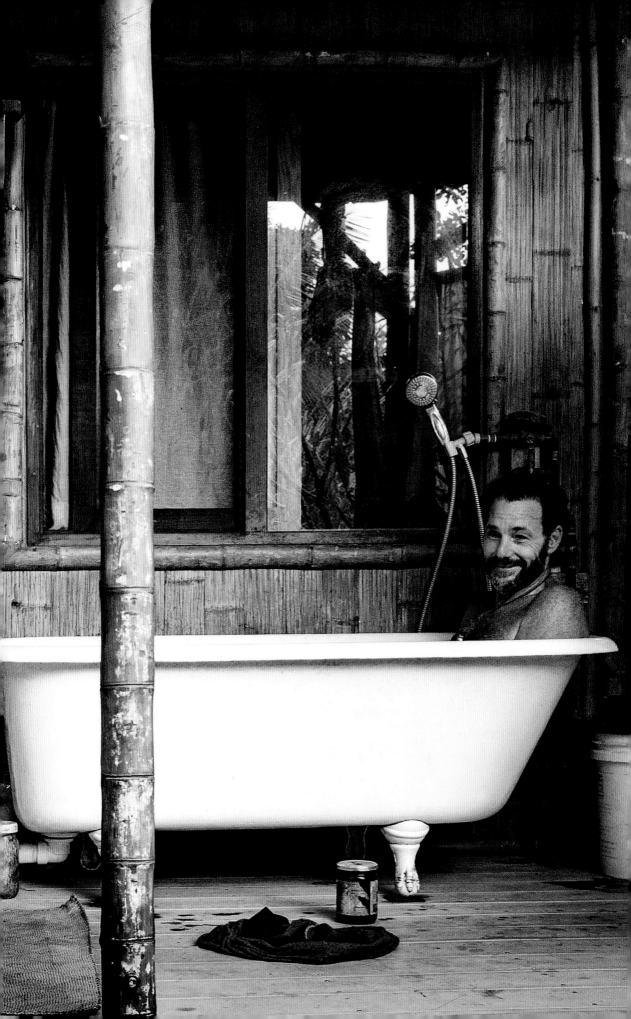

For the opportunity to be part of your infantry. Warriors of light and peace make us unite," she sings. A surprising number of people know the words and sing along.

Next up is a man from St. Croix who introduces himself as "Peacemaker of The Realm." He does an impressive dancehall rap about chakras, ancient Egypt, and Quetzalcoatl. Then, various WWOOFERs sing call-and-response Kirtan standards accompanied by bongo drums and a coconut shaker. Jeanne's boyfriend gives the weekly farmer's almanac news bulletin that highlights the most successful crops (spoiler alert: the papaya, lilikoi, and taro root are going like gangbusters). And on it goes.

Just ten miles down the road is the town of Hana with its primordial beaches. They're known and named for their trippy, volcanic colors—as in Red Beach or Black Beach. Although Hana has just a few stores, old wooden sugar plantation buildings, and one luxury hotel, it's positively urbane compared to Kipahulu. The town has both a "gyp" and a "set" side. There are the WWOOF farms with roadside stands selling abiu fruit, turmeric, organic coffee, and no less than five types of banana bread. (Banana bread quantity and quality is weighed with Michelin star seriousness around here.) And then there are the compounds of the groovily famous: Kris Kristofferson's, Woody Harrelson's, and the late George Harrison's. I stop by one belonging to the fashion photographer

Above: Puka Puka gallery directors Alizé de Rosnay and Nathan Howe at their home in Pa'ia.

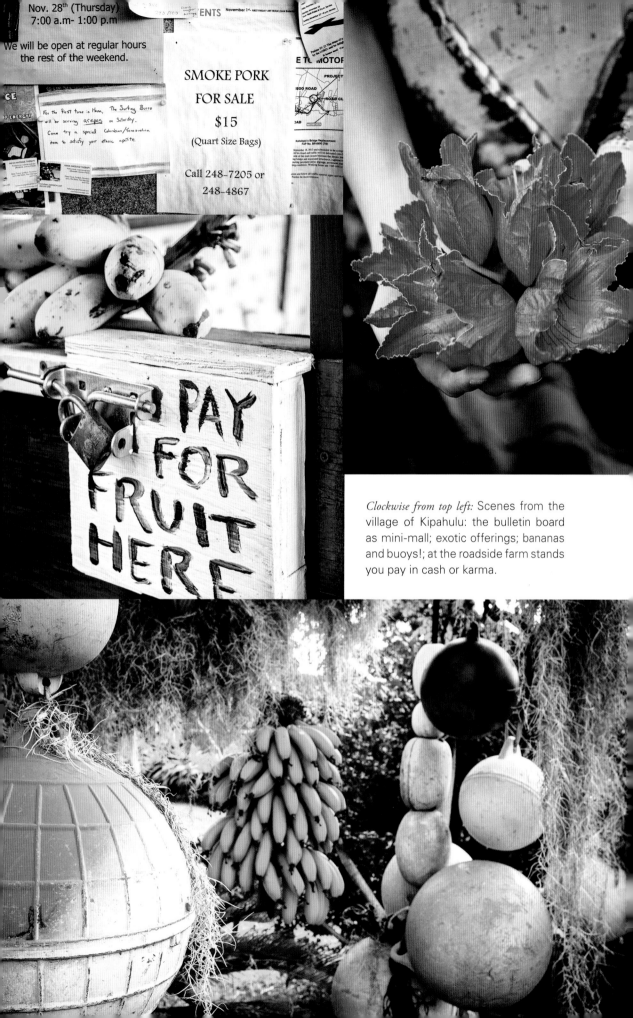

Nov. 28th (Thursday)
7:00 a.m- 1:00 p.m
We will be open at regular hours
the rest of the weekend.

For the first time in Hana, The Surfing Burro
will be serving arepas on Saturday.
Come try a special Colombian/Venezuelan
item to satisfy your ethnic apetite.

SMOKE PORK
FOR SALE
$15
(Quart Size Bags)

Call 248-7205 or
248-4867

PAY FOR FRUIT HERE

Clockwise from top left: Scenes from the village of Kipahulu: the bulletin board as mini-mall; exotic offerings; bananas and buoys!; at the roadside farm stands you pay in cash or karma.

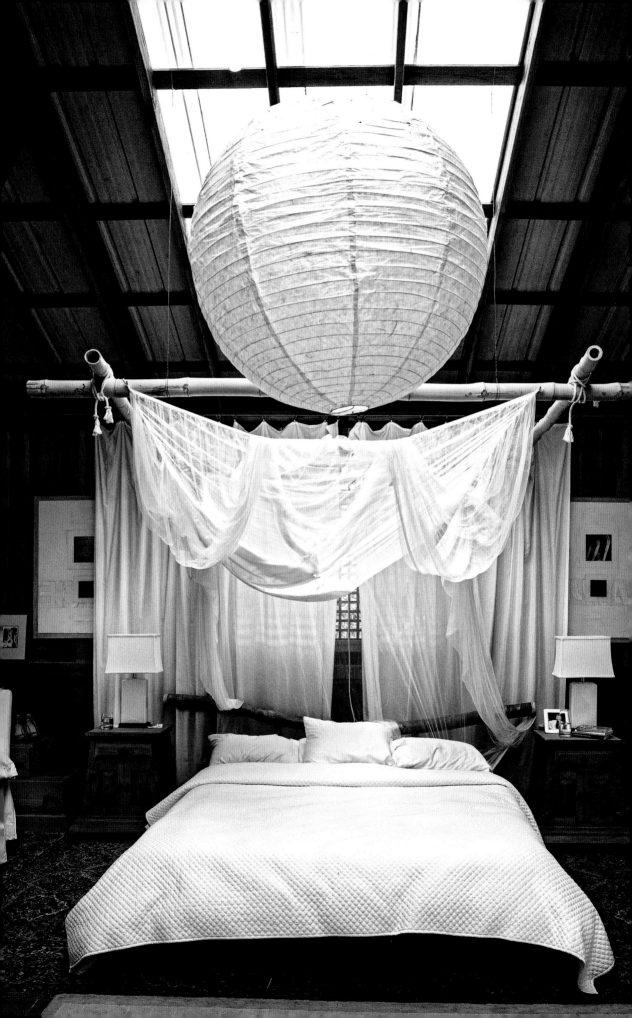

David LaChapelle. Amid a dense patch of banana leaves is a marble bathtub imported from Rome. A miniature, wooden barn left over from a Motorola commercial is now filled with goats—with names like Lady Baba and Whitney—that provide milk, and a rusty Mercedes painted in fuchsia camouflage runs on vegetable oil (when it runs, that is). The sound of techno music emanates from the jungle where a crew of tattooed guys with sculptural facial hair saw up planks of wood to build a mini chapel.

Hana's two worlds mingle at various weekly events like Hana Farms' Pizza Night and Woody Harrelson's FriDaze gathering at his house (it starts at 4:20, get it?), where various cannabis-based parlor games ensue.

The road back to civilization ends in a funky, old sugar mill town on Maui's North Shore called Pa'ia. (Note: Most of the big resorts on Maui were built on the south side of the island because of the tame, dependable climate. Naturally, I avoid those places.) Pa'ia is the big wave surf and kiteboard center of Hawaii. Surfer Laird Hamilton lives here, and around town you can see boards with the logo, "Blame it on Laird" (Laird thought it was so funny, that he bought the company). The après scene plays out at Charley's, a saloon frequented by Willie Nelson and his son Lukas (see Chapter 7). But when I arrive in Pa'ia, it feels like an aloha version of a cool, arty neighborhood in New York City.

Case in point is Puka Puka, a contemporary art gallery/boutique run by the young gypset couple Nathan Howe and Alizé de Rosnay—that sells everything from Hussein Chalayan dresses to vintage surf photography to 1940s Tahitian music produced by Yves Roche. Nathan is an experimental sound artist and Alizé is a former art director of an advertising firm. And of course, with résumés like that, there is a New York City connection. The couple moved to Pa'ia from Manhattan a few years ago to take over Alizé's family gallery. It was a homecoming of sorts. Alizé's grandfather is John Severson, the legendary surf photographer who started *SURFER* magazine and moved to Maui in the 1960s. And her father is Arnaud de Rosnay, the famed French playboy-turned-activist who windsurfed between political conflict zones and was lost at sea between Taiwan and China in 1984.

Alizé and Nathan live in an old, one room potter's shed behind Puka Puka. I would call it modest if not for its beachfront location on a fantastic surf break. I stop by one morning to join them for a hike. We fuel up on homemade kombucha and pumpkin gingerbread cake. And a swig of fermented Noni fruit that they picked on a camping trip to Kipahulu. "The taste could be described as "baby's puke," says Nathan. "But a shot a day keeps the doctor away." He wasn't kidding about the taste.

An enchanting bedroom at artist Tom Sewell's Pa'ia retreat—love the bamboo canopy!
Following pages (left): Photographer David LaChapelle's Italian marble bathtub in the jungle of his off-the-grid compound in Hana. *Right:* A wooden barn left over from a Motorola commercial is now filled with goats—with names like Lady Baba and Whitney—that provide dairy products to LaChapelle's home.

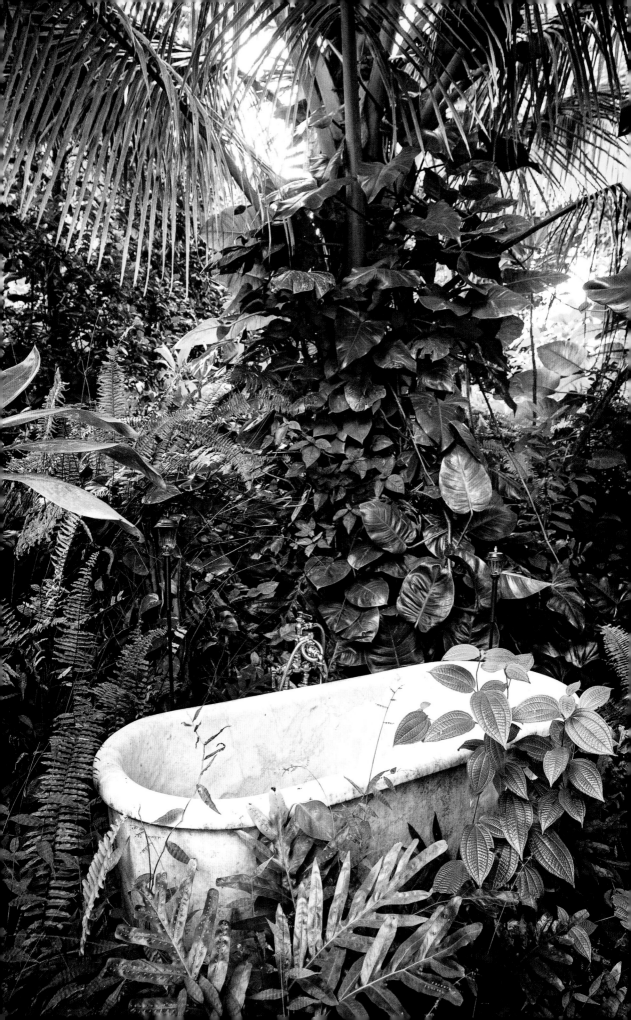

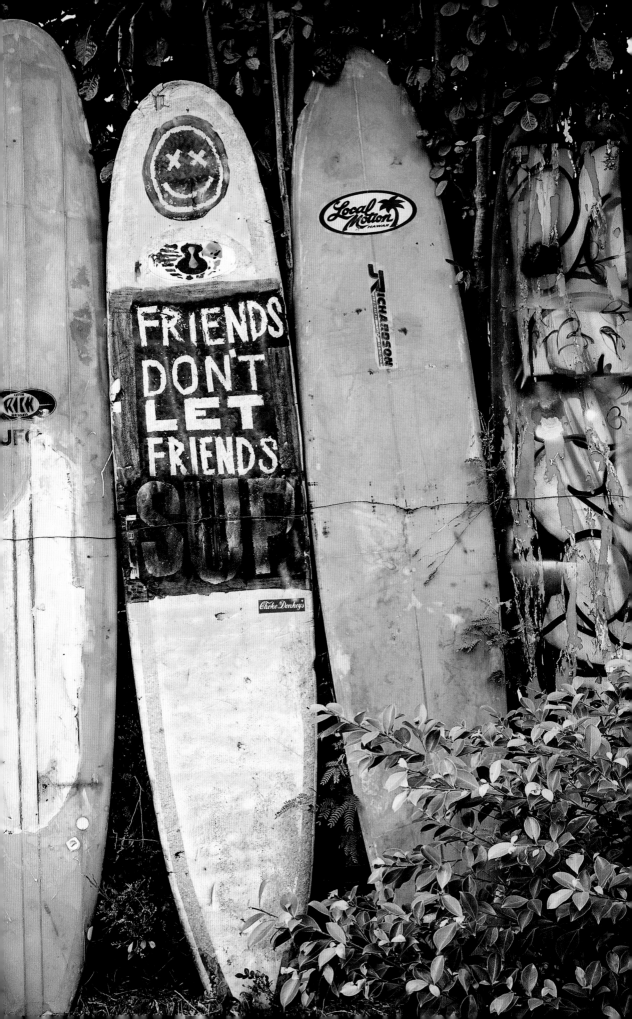

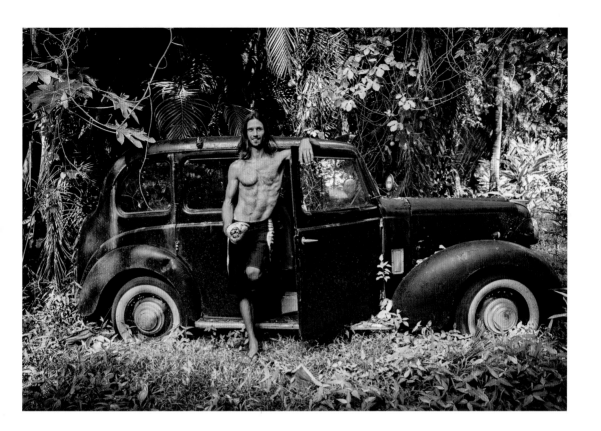

We drive about forty-five minutes into the lush Lao Valley, take off our shoes and make our way up the steep fern forest, wispy pine needles underfoot as we clutch various vines and branches to keep from tumbling backwards. It feels convincingly primal. Alizé tells me about growing up shuttling between Mustique, London, and Maui in the late 1980s with her mother Jenna, a windsurfing champion and *Vogue* cover girl. "My mother taught me to surf and windsurf during our precious off-time by the sea. Maui was our *plein air* studio and playground."

Back at Puka Puka, I end up buying a 1970s photo by John Severson of a bronzed nature man journeying across a rugged Maui mountainside in nothing but a loincloth and a shell necklace. His name is James Cook Loomis, aka Captain Jim, a beat poet-artist, mathematician, and author who sometimes wrote books under the pen name Bong Quixote. He lived in a tree house in the Maui jungle and according to my research (on Google) he was blessed with the "physique of Adonis" and "stopped cutting his beard twenty years ago." In other words, he's my kind of guy. Alas, the half naked young guy in my new photo is, at this point, almost eighty-years old. But I know where I can still find people like him—if I trek far enough down the road through Hana and into the Hawaiian wild.

Above: Out of gas, but plenty of coconuts.
Opposite: Old surfboards line the side of the road in Pa'ia.

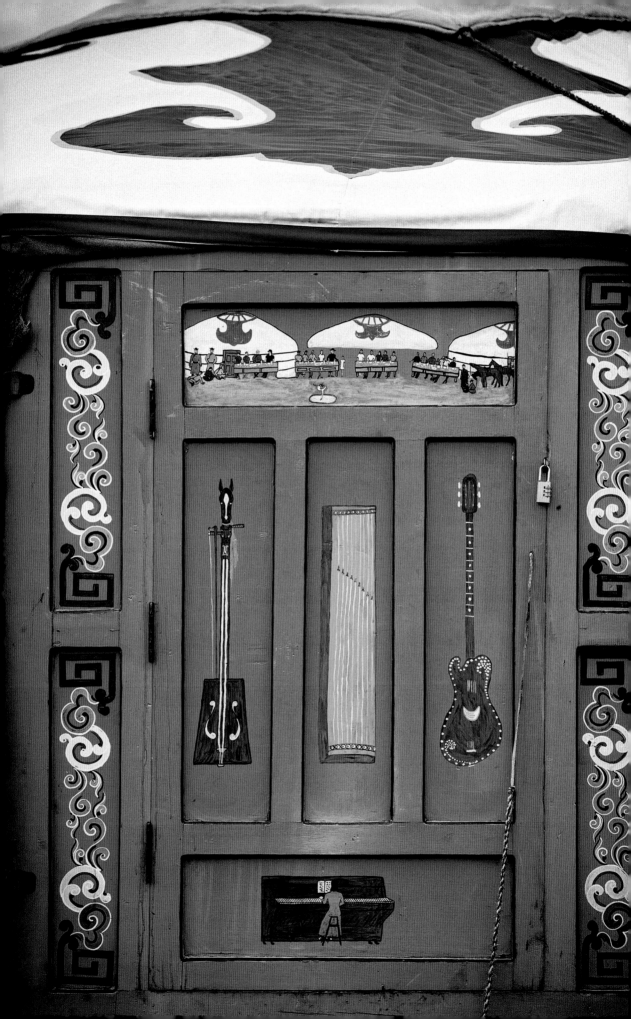

Nomad Chic

MONGOLIA

Gypset Rule #10: When traveling to Mongolia make sure it's summer and to bring trail mix and a leopard-print fez.

A man with lopsided, spiky white hair, worn tuxedo tails, and purple knee socks is parading around in front of the yurts shouting orders. "Dress for dinner," he yells in a thick German accent. "Don't be late, eh. Don't be late." I'm at the Genghis Khan Polo Club, an eccentric, off-the-grid outpost in central Mongolia that's a six-hour drive from the capital of Ulan Bator over dirt and rocks.

About thirty white felt yurts, or *gers* as they are called in Mongolia, are clustered in a camp along a ridge. There is nothing else in sight except for rolling hills, big skies, and herds of yak. I toss on my leopard-print fez and stuff inside the candlelit dining ger. Dozens of people, some wearing Mongolian evening dresses, all sit around the tables, including the Harvard polo team, a Buddhist quantum physicist living in London, a contemporary art scholar from Beijing, and a teenage contortionist from a nearby village in a pink glitter body suit.

Christopher Giercke, the man I encountered outside, is presiding over the room like a French court, giving a speech about the beginning of civilization and calling on unsuspecting guests to give impromptu presentations. Waiters in headlamps, who double as the polo team, are serving mutton stew and imported red wine.

"Chopin! I want to hear some Chopin!" Christopher commands, as a studious looking young Mongolian woman, whom Christopher sponsored to study in Italy, begins an impeccable recital on a grand piano. I'm glad I'm wearing my fancy fez.

Each yurt, or "ger" as they're called in Mongolia, is decorated with a different door motif.
Following pages: The interior of Christopher and Enkhe Giercke's ger at the Genghis Khan Polo Club.

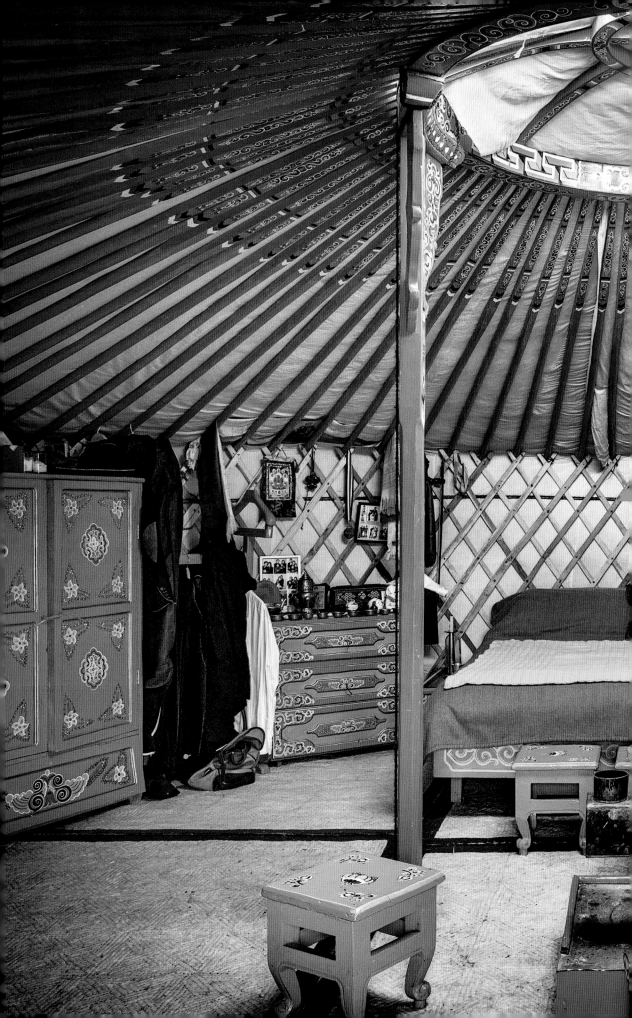

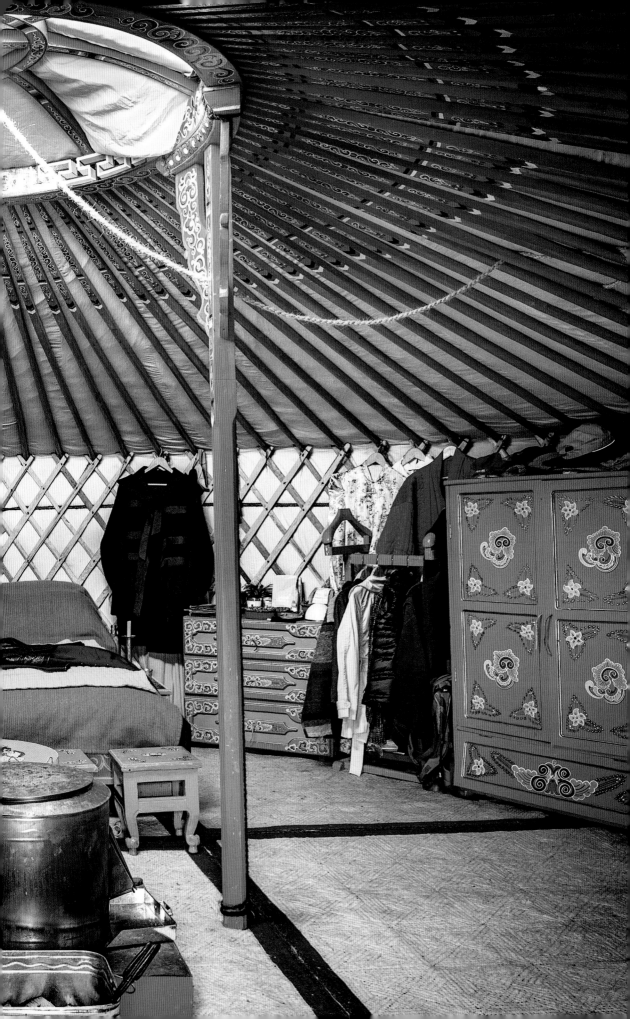

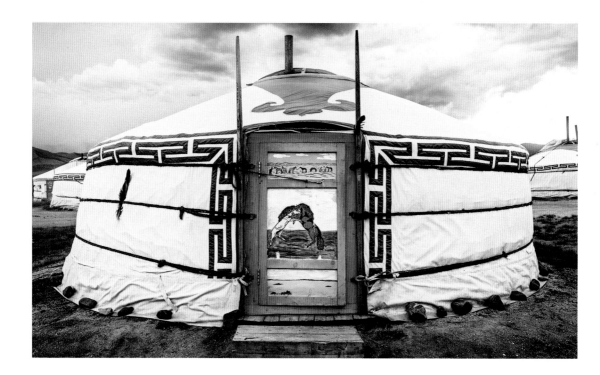

Mongolia is a gypsetter's Mecca. It's one of the few countries in the world that's still nomadic (thirty-five percent of the population are pastoral nomads). There are few fences, few roads, and no crowds even in August. (Horses far outnumber people.) Throat singing is popular and people dress in traditional "deels": long robes that have an exotic Chinese, Siberian, galactic-warrior look. After being suppressed by the Soviets who ruled Mongolia from the 1920s to 1991, Buddhism has resurged as the reigning religion, attracting Zen pilgrims last seen in Bhutan or the Jokhang temple in Lhasa.

In many of the far-flung boho enclaves I've traveled to for this book, yurts are the architectural symbol of freedom—from The Springs to Topanga Canyon to Maui. There's something about the temporary, round structure that encourages the mind to wander. So why not go straight to the source, the birthplace of the yurt? So what if the Genghis Khan Polo Club, part eco-luxury safari, part Burning Man, and part intellectual boot camp, is an anomaly for Mongolia. It qualifies as one of the most gypset places I've ever been.

The next morning, the earth-shaking bass of a male baritone awakens me. It's Tsogt, the Polo Club's burly guardian angel, who's also a Paris-trained opera singer. Wearing his Mongol warrior hat, he's teaching some of the Harvard kids archery out in the field. I can hear Christopher stomping around announcing a mandatory expedition to the nearby town of Karakorum. "It's the seat of the Mongol empire, ok? Civilization started there, ok?" he yells to no one in particular.

Christopher, who's in his sixties, dresses like a Carnaby Street Edwardian punk. He lives between Kathmandu, Mongolia, and Paris with his Mongolian wife Enkhe and their three children,

Above: A ger at the Genghis Khan Polo Club.

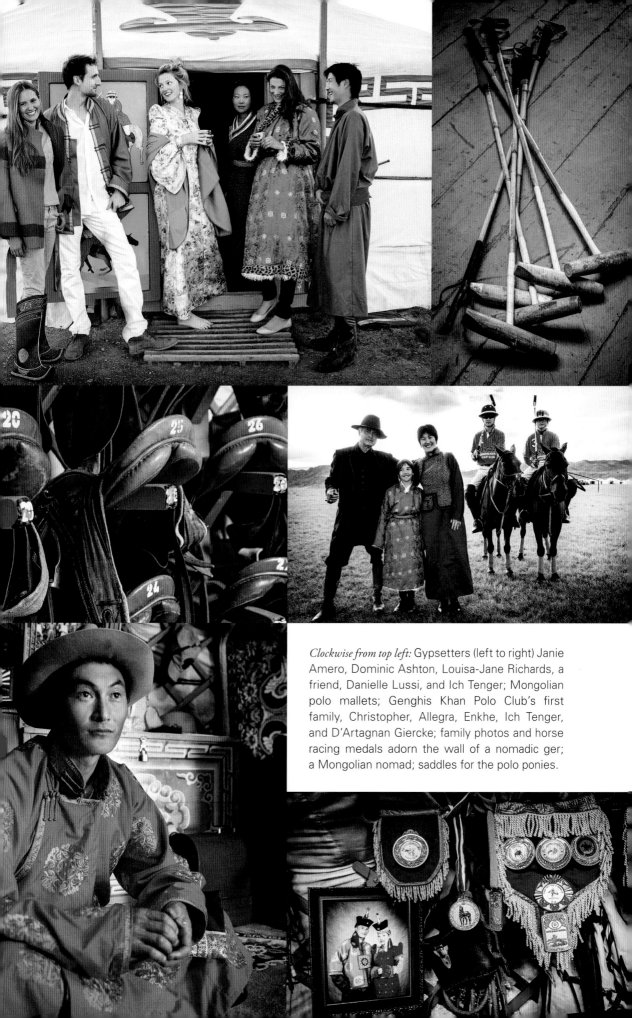

Clockwise from top left: Gypsetters (left to right) Janie Amero, Dominic Ashton, Louisa-Jane Richards, a friend, Danielle Lussi, and Ich Tenger; Mongolian polo mallets; Genghis Khan Polo Club's first family, Christopher, Allegra, Enkhe, Ich Tenger, and D'Artagnan Giercke; family photos and horse racing medals adorn the wall of a nomadic ger; a Mongolian nomad; saddles for the polo ponies.

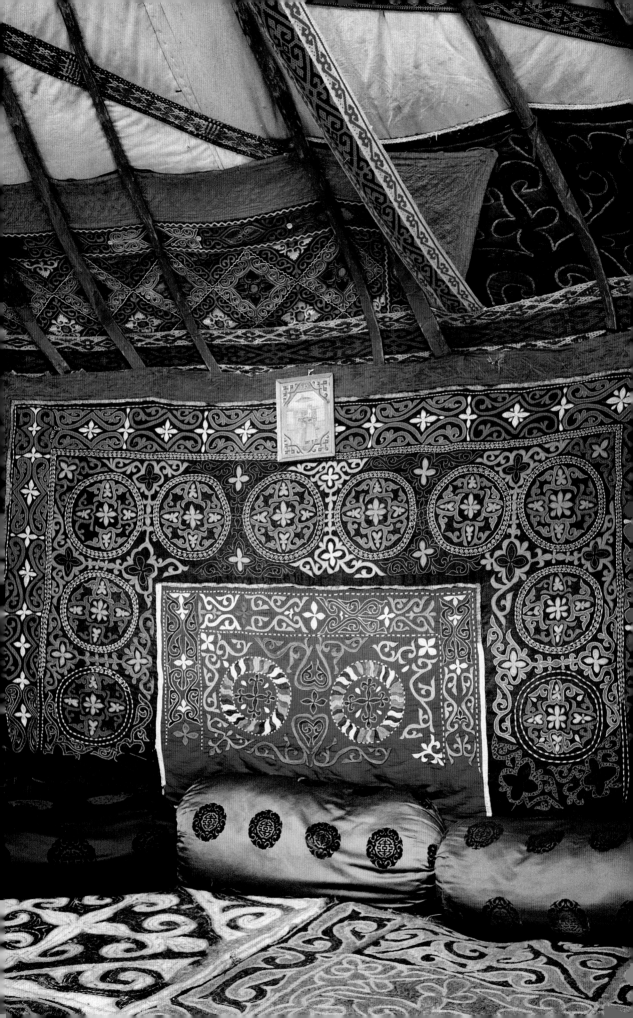

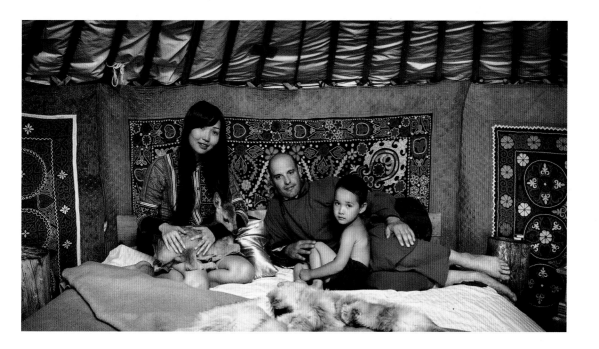

Ich Tenger, 18; D'Artagnan, 16; and Allegra, 9. Christopher met Enkhe in the mid-1990s on a film shoot, and started the Polo Club a few years later in the Orkhon Valley in an attempt to resurrect the sport used by Genghis Khan in the thirteenth and fourteenth centuries to train his fierce warriors when he ruled the world with his Mongol Empire.

"The point is to elevate Mongol culture and help the image of the country," Christopher explained. He succeeded in getting polo included in the national Nadaam Festival, an annual event held in July in Ulan Bator where countrymen compete in archery, wrestling, and horse racing. Pre-teenage jockeys race over the hills—some bareback—with their brightly colored, superhero-style capes billowing in the wind. This year, Christopher invited the Harvard team over to play Mongolia's national team (which is actually his Genghis Khan Polo Club team). "The prime minister was very pleased," said Christopher.

Christopher has dabbled in just about everything: in the 1970s, he worked on *Apocalypse Now,* and was responsible for rounding up local Filipinos to play headhunters. In the 1980s, he was managing a punk band in New York City. More recently, he has been working with Hermès, securing their supply of coveted Mongolian cashmere. Patrick Guerran-Hermès and designer Christophe Lemaire are frequent guests at the Polo Club.

Christopher, a practicing Buddhist, has art directed the entire camp in a luxe Zen way. My ger has Hermès blankets on the bed and a plush, white felt carpet made from local goat covering the floor. There's no electricity (Christopher hates the sound of generators) but young Mongol women in colorful deels rush around delivering hot tea and biscuits and tend to the wood burning stoves

Above: Narangerel Batjargal and Hamid Sardar with their son in their family ger in the northern Lake Khovsgol region. *Opposite:* An interior of a ger decorated with textiles from Kazakhstan. *Following pages:* The tricked-out bathing ger at Hamid Sardar's camp. *Pages 162–163:* A yak grazes in the Orkhon Valley.

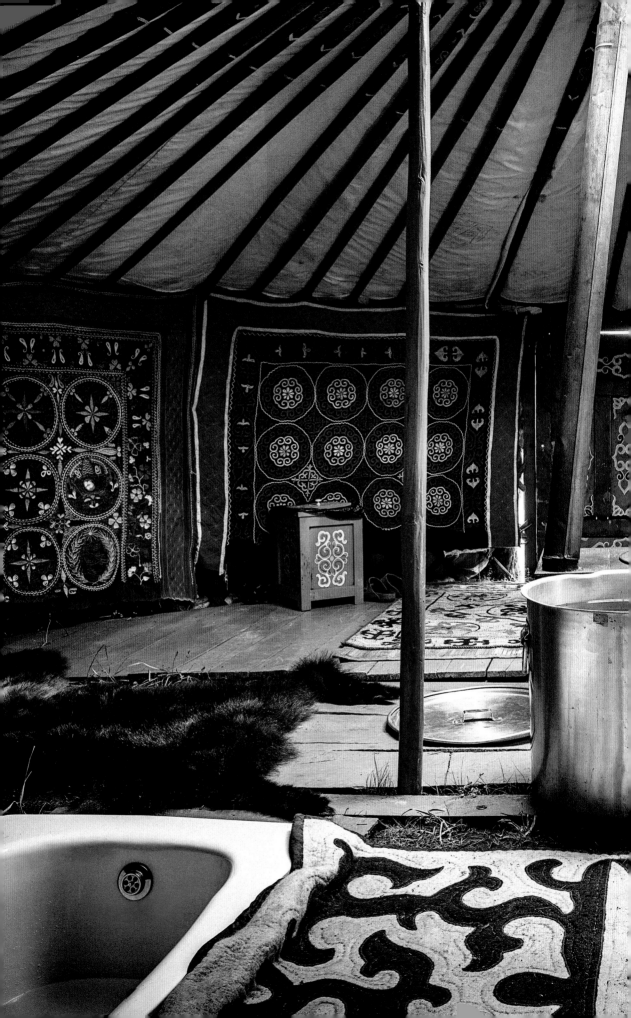

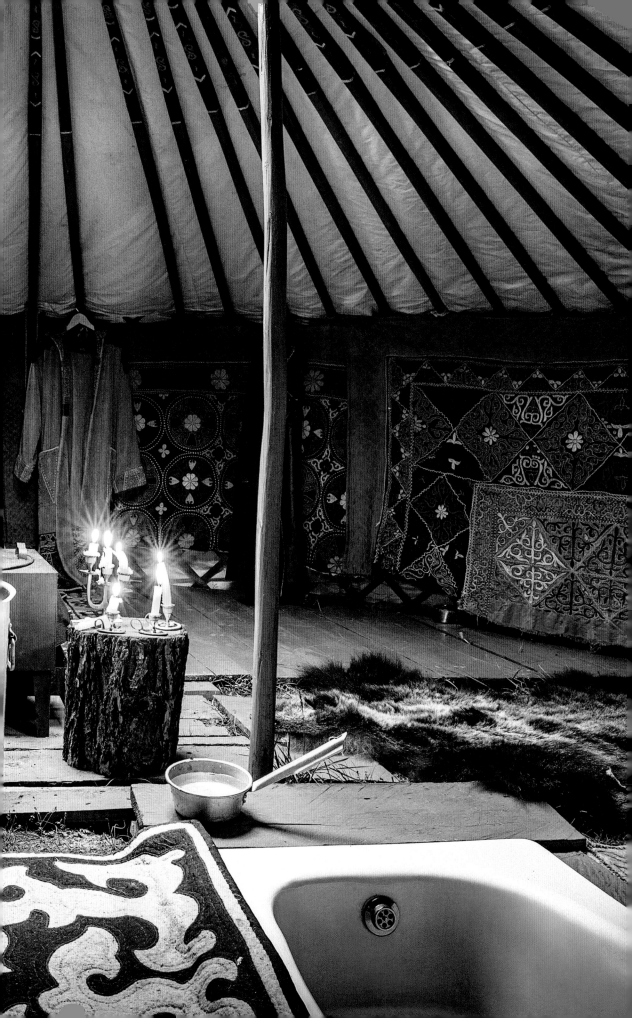

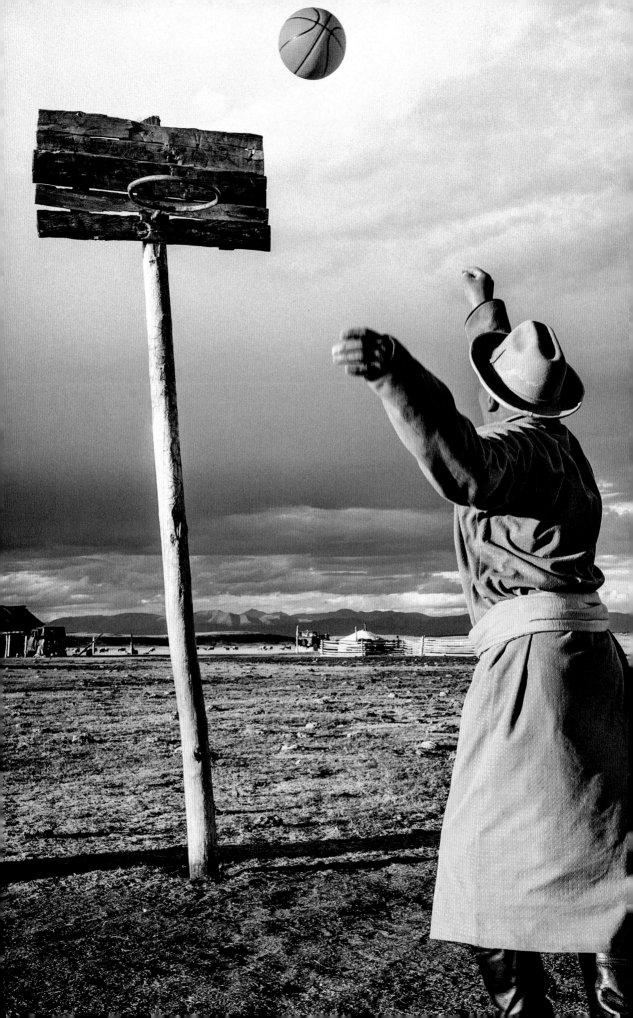

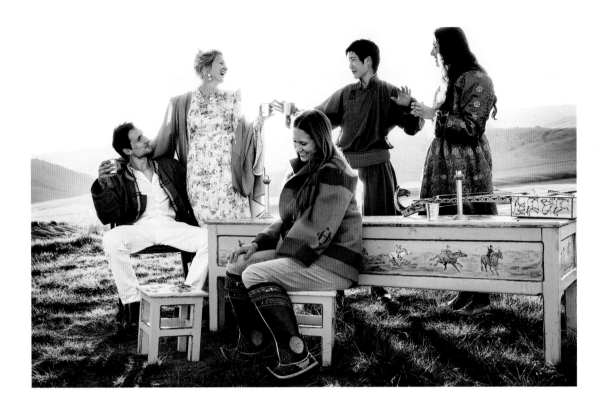

in the middle of every ger; I call it "ger service." Gers have been designated for massage, yoga, breakfast, and polo gear. Bathing is done in two Japanese soaking tubs heated by wood and yak dung that feel, to me at least, on par with the best Kyoto ryokans.

Mongolia's winters are some of the coldest and most severe in the world with temps averaging minus thirty-degrees Fahrenheit—but summer is a carefree, blissful time on the bucolic grasslands. It's extremely hot one afternoon, so I throw on my bikini and head down to the sandy riverbank. I spend hours sunbathing and splashing in the cool, mountain water. While dozing on a big rock, I'm awoken by a herd of prehistoric-looking yak headed right towards me. I bolt up and out of the way giggling at the irony—normally in mid-July, I'm dodging the trendies on the beach in Montauk.

On the Polo Club's website it says the club is private and only for those who are "invited." (Guests don't pay but they do leave "contributions.") Which I thought was very gypset. But how do you get invited if you don't know Christopher? I had a hard time getting him to return my emails until a mutual friend intervened. But there's definitely room for the committed crasher.

"My father likes to be interested," explained Ich Tenger, Christopher's eldest son. "Anyone that interests him can come."

My last night at the Polo Club, there's a going away party for the Harvard team down by the polo fields. The whole camp crams into the tack ger with saddles and bridles lining the walls. Hunks of blowtorched charred goat are served, chased with shots of vodka. The local Mongols

Above: Friends take in the sunset at the Genghis Khan Polo Club.
Previous pages (left): A weathered ger door.
Right: A nomad shoots hoops on the steppe in the north of Mongolia.

Clockwise from top left: Archery is a popular pastime in Mongolia; kids seem really happy here; polo players practice at the Genghis Khan Polo Club; a reindeer woman in the north of Mongolia; a remnant of the Soviet Empire; a painting decorates a Soviet-era airport in the north.

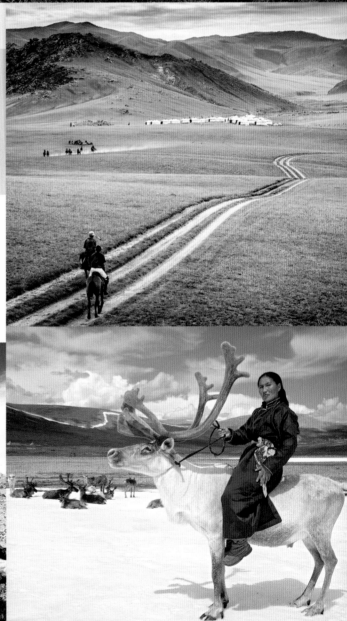

take turns standing up and belting out sincere, traditional ballads about farming and fertility. I'm getting increasingly drunk when I hazily notice Enkhe, Christopher's wife, pointing right at me. She seems to be commanding me to perform. So, dutifully I stand up and loudly sing the only national anthem I know the words to, only because my parents used to play it incessantly: "Hotel California." I tick through every verse, illustrating my passion with air guitar, drum rolls, and leg kicks. The next morning I wonder if I have become more "interesting," or much less so, to Christopher.

"Be careful. If you get too close to him he will bite you," was the warning given to me at the Polo Club regarding my next stop, a camp in the north near the border of Siberia and run by Hamid Sarder, a Harvard-educated, Iranian-American Tibetan scholar and filmmaker.

I'm pondering the cryptic warning about Hamid as I fly to the northern town of Mörön (yes, that's where the word originated). A driver leads me to an old Russian communist-era van and writes down the number twelve on a piece of paper: twelve, as in a twelve-hour drive. No roads and no GPS, just grass, rocks, and mud—and more mud—made bearable by my perfunctory cocktail of vodka and canned peach juice.

Mongolia has recently found itself in the midst of a multi-billion dollar mining boom with discoveries of vast deposits of gold, coal, and ore, but most of the country still remains in post-Soviet dilapidation and lacks basic infrastructure—like roads. When the driver gets lost and we stop at a lone ger to ask directions, a family of six invites us inside and serves us cups of airag (fermented mare's milk) and hardened curd. The fermented milk tastes like a sort of dairy kombucha—alive, kicking, and lingering. The more we get lost and the more gers we visit (and the more airag I drink) I realize that each ger is identically arranged according to tradition and superstition. For example, the man's side of the ger is the west front where saddles are kept. The guests sit in the north front and the kitchen knives are stashed over the door to keep out bad spirits.

Needless to say, when we finally reach Hamid's camp, there are no Hermès blankets. The camp is an artist's compound with a few threadbare gers, some filled with photography and film editing equipment. Hamid is nowhere to be found. His young Mongolian wife tells me he's off in the remote, forested area northwest of Lake Khovsgol documenting the Tsaatan reindeer people, a vestige of old tribal Mongolia. He returns a few days later on a galloping horse, and I tease him about the drive. "It's the only thing that keeps the tourists away," he replies as his intense green eyes flicker with mischief. Hamid suggests that we cruise around and visit some of the neighbors, pretty much the only social pastime around here. So we pile into his Land Cruiser and make our way over the rustic terrain with snowcapped Mt. Khovsgol in the background and thick pine forests. We pick

A cute baby deer we met along the way—somehow she was already named Bambi.

up a local elder type with few teeth named Wolf Caller. (The area is known for its shamans and superstitions.) Wolf Caller tries to sell me a plastic wolf anklebone saying it will act as a good luck charm against things like airplane crashes—I can't tell if he's joking.

Other nomads are out in the midday sun playing basketball, some are peeling around on dirt bikes and horses, and some are spruced up on their way to a local Nadaam festival—a sort of pick up scene where young people make dates by exchanging GPS coordinates instead of email addresses.

"It's a lot like the American West," Hamid observes. He has been coming to Mongolia since the early 1990s and now spends part of the year in Paris. "Exploration and horizon are still a vital part of the Western imagination. But once you settle down in a place and put a fence around it, you have this phenomenon called boredom. Boredom can be devastating."

We stop at a ger belonging to a prosperous semi-nomadic family who winters in a condo in Ulan Bator. They've made their money by owning racehorses that compete at Nadaam. Their ger feels very country western. They wear big felt hats, orange deels, and pointy boots. In the far corner by the family shrine, there are horse racing medals, ornamented stirrups, and a shudraga—an elongated string and bow instrument used for songs about livestock and love. We drink more airag.

Then it's off to take a dip in the healing springs, various pools of sulfuric water that are believed to cure a laundry list of ailments from a broken heart to weak eyes. Radiohead is playing on the stereo and we cruise along the steppe in the afternoon sun. Wolf Caller begins to throat sing along to "Karma Police" and at this moment, I feel very much like a nomad. I've finally arrived at everywhere.

Above: Rush hour on the steppe.
Opposite: London/Burma-based Louisa-Jane Richards takes a barefoot stroll.

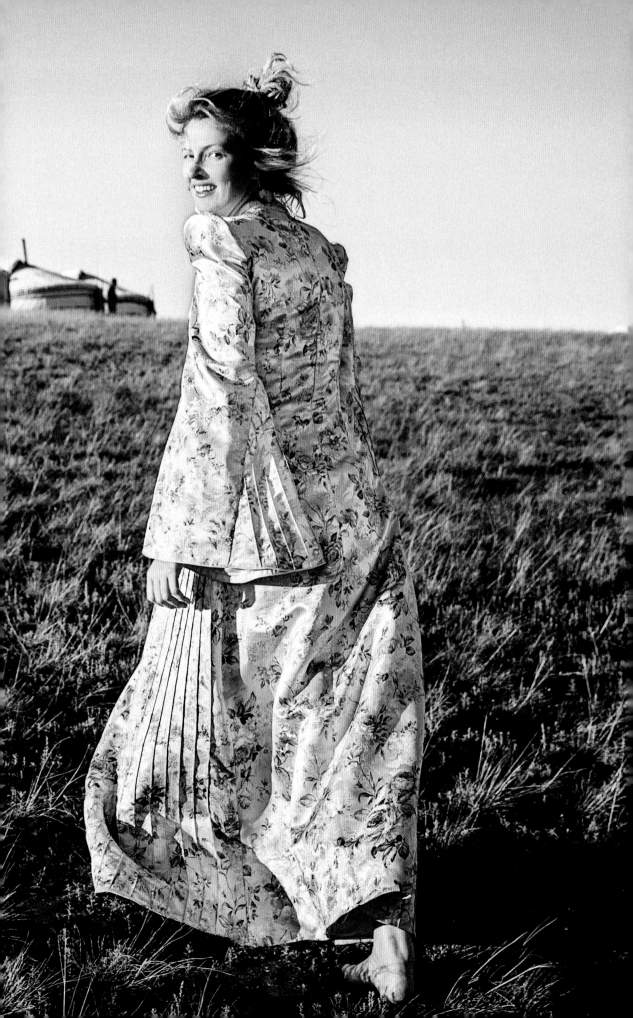

Address Directory

BALI, INDONESIA

BAMBU INDHA

John Hardy's innovative eco-hotel
with unconventional lodging options
including Javanese bridal huts
and a modernist pagoda.
Banjar Baung, Desa Sayan,
Ubud, Bali 80571, Indonesia
Tel: +62-361-8868807
www.bambuhindah.com

ALCHEMY

A raw foods café with an outdoor
terrace that's the center of the Ubud
clean living scene.
Ubud, Bali 80571, Indonesia
Tel: +62-0361-971981
www.alchemybali.com

GUÉTHARY, FRANCE

LE MADRID

A Basque restaurant, bar, and small
guest- house in the center of town
is where the gypsetters are.
563 av du Général de Gaulle, 64210
Tel: +33-559265212
www.lemadrid.com

KOSTALDEA

A cheerful outdoor café overlooking
the main beach, where the surf crowd
gathers for lunch—(it's only open
if the weather is good).
Promenade de la Plage, 64210.
Tel: +33-616616100

MARRAKECH, MOROCCO

RIAD EL FENN

Vanessa Branson's boho luxe
boutique hotel in a converted riad
with leafy courtyards, dipping pools,
and a Berber-styled roof terrace.
2 Derb Moullay Abdullah Ben Hezzian,
Bab El Ksour, Merrakech, 40000
Tel: + 212-5244-41210
www.elfenn.com

LE JARDIN

The Marrakech intellegencia can be
found in the garden of this Medina
restaurant during lazy afternoon lunches.
32 Souk El Jeld.
Sidi Abdelaziz, Marrakech, 40000
Tel: +212-5243-78295
www.lejardin.ma

HYDRA, GREECE

GITONIKO

A traditional taverna with a roof terrace
serving up fresh eggplant salad;
stuffed grape leaves; and grilled calamari
caught just offshore.

PIRATEBAR

An outdoor café on the port where
the art world gathers for late breakfasts
and late nights.
www.piratebar.gr

CUIXMALA, MEXICO

CUIXMALA

Alix Goldsmith operates Cuixmala
as a luxe estate with several amazingly chic
casitas and bungalows for rent among
miles of empty beach and herds of zebra.
Tel: +52-312-316-0300
www.cuixmala.com

CAREYES

Careyes is another resort just up the road,
where you can rent colorful casitas
and decadent villas.
Carr. Barra De Navidad Jalisco, Mexico
Tel: +52-315-351-0320
www.careyes.com.mx

THE SPRINGS, USA

FIREPLACE PROJECT

The Fireplace Project is a contemporary art
space in a converted automotive garage with
lively exhibition openings in the summer.
851 Springs Fireplace Road,
East Hampton, NY 11937
Tel: +1-631-324-4666
www.thefireplaceproject.com

POLLACK-KRASNER HOUSE

The Pollack-Krasner House
and Study Center is both a museum
and shrine, where visitors can
wander around and check out Jackson
Pollack's art studio and his collection
of jazz records.
830 Springs-Fireplace Road,
East Hampton, NY 11937
Tel: +1-631-324-4929
www.pkhouse.org

WILD BELLE

MAMA RUISA

While on tour, Wild Belle's favorite
places are… Mama Ruisa, a seven-room
French styled Brazilian boutique hotel
set in a leafy garden in the groovy Santa
Teresa neighborhood of Rio de Janeiro.
Cal Rua Santa Cristina,
132 - Santa Teresa, Rio de Janeiro, Brazil
Tel: +55-21-2242-1281
www.mamaruisa.com

HOTEL CONGRESS

A classic "old west" style hotel
in downtown Tucson with
a very happening live music club.
311 E Congress St, Tucson, AZ
Tel: +1-520-622-8848
www.hotelcongress.com

TOPANGA CANYON, USA

INN OF THE SEVENTH RAY

Local gypsetters love this Topanga
hippie institution, especially
during Sunday brunch.
128 Old Topanga Canyon Rd.
Tel: +1-310-455-1311
www.innoftheseventhray.com

HIDDEN TREASURES

A funky vintage shop with a definitive
stock of moccasins, ponchos, and Native
American textiles.
154 S Topanga Canyon Blvd.
Tel: +1-310-455-2998

MAUI, USA

HALEMANO

The gypset Four Seasons with several
yurts and Balinesian huts on a paradisical
property overlooking the Pacific Ocean.
Kitchen and bathrooms are communal.
Don't be put off if the website says its
"for sale."
Hana Hwy., Maui, Hawaii
Tel: +1-808-248-7071
www.halemanomaui.com

CAFÉ ATTITUDE

The Sunday evening hootenanny
on a private ranch is a weekly institution.
Homegrown, organic dinners are served.
Bring your maracas and poems.
The sauna is clothing optional.
Ask around in Kipahulu for directions.
Tel: +1-917-748-6600
www.angelheart.com

MONGOLIA

GENGHIS KHAN POLO CLUB

A luxe yurt camp in the Orkhon Valley with
polo facilities run by Christopher Giercke.
Reservations are not guaranteed
as technically you have to be "invited,"
but if you plead your case convincingly
things might work out.
Tel: +976-8811-4014
www.genhiskahnpolo.com

WIND HORSE EXPEDITIONS

This yurt camp in the north near the Siberian
border is run by Tibetan scholar/ filmmaker
Hamid Sardar. It's focused on horse riding
excursions, such as visiting a remote tribe
of reindeer people.
E-mail Hamid to find out more.
mongolwindhorse@gmail.com

Following pages: Local wares at Atelier Moro, an exquisitely curated boutique owned
by Colombian expat Viviana Gonzalez, in Marrakech, Morocco.

ACKNOWLEDGMENTS

The author wishes to thank the following people for their contributions to the book:
The Springs: Oliver Ryan, Mary Bayes Ryan, Maxwell Ryan, John Benton, Lorraine Kirk, Leilani Bishop, Stephanie Paine, Patti Stoecker, and Grant Monahan.
Guéthary: Alexis de Brosses, Nadege Winter, and Xavier Manuel Magescas.
Marrakech: Sebastian de Gzell, Kamal Laftimi, Laila Hida, Laetitia Trouillet, Hassan Hajjaj, Artsi Ifrach, Maryam Montague, Danny Moynihan, Maggie Hund/HL Group, and Chakib Ghadouani/Morocco National Tourist Office.
Hydra: Mirabelle Marden, Brice Marden, Helen Marden, Gemma Ingalls, Dakis Joannou, and Mark Borthwick.
Cuixmala: Alix Goldsmith and Goffredo Marcaccini, Philippe and Priscilla Moellhausen, Viviana Dean and Diego Quiñones, Sebastian and Cheryl Giefer, and Whitney Sadhu.
Bali: John Hardy, Elora Hardy, Maya Ablanese, Diane Lion Giustiniani, Meri, Jane Hawkins, Elaina Myers, Sybil Steele, Shelby Meade, Dustin Humphrey, Tim and Seewah Russo, and Ashley and Cherry Bickerton.
Topanga: Shiva Rose, Carly Jo and Matthew Morgan, Saskia, Angela Lindvall, Sukhdev Jackson, Lukas Nelson and PoTR, Uschi Obermaier, Taiana Giefer, Toree Arntz, and Deborah Schoeneman.
Maui: Nathan Howe, Alizé de Rosnay, Monyca Byrne-Wickey, Tom Sewell, Rebeka Kuby, Shawn Spillett, Sabrina Buell, Craig Maldonado, Vanessa Grigoriades, Jeanne Angelheart, Kipahulu Martin, and Halemano Siddho.
Wild Belle: Elliot Bergman, Natalie Bergman, and Jaclyn Hodes.
Mongolia: Christopher and Enkhe Gierke, Louisa-Jane Richards, Dominic Ashton, Ich Tenger, Janie Amero, Danielle Lussi, Hamid Sardar, Narangerel Batjargal, Khasar Sandag, and Wolf Caller.

Honorable mention to the talented Assouline group: Martine and Prosper Assouline, Esther Kremer, Prudence Dudan, Aaron Bogart, Rebecca Stepler, Stephanie Labeille-Sczyba, and Eduard de Lange.
The publisher would also like to thank Oscar Espaillat, Corbis; Regina Alivisatos, DESTE Foundation for Contemporary Art; Garance Doré; Sarah Zimmer, Getty Images; Brian Guido; David LaChapelle; Nigel Boekee, Michele Filomeno France; Eric Striffler; Kumi Tanimura; Billy Vong, Trunk Archive; Eirini Vourloumis.
Special thanks to the Gypset team photographers Brian Hodges and Daniele Albright for the grand adventures and making the Gypset world come into beautiful, poetic focus.
Super agent Meg Thompson and editor extraordinaire Adam Fisher. Here's to more, more, more!
And *muy especial* thanks to Jason Miller for his continued Gypset support. And to my lovely daughter, Tuesday, who's always game for adventure.
Paz y todos, xx Julia

PHOTO CREDITS